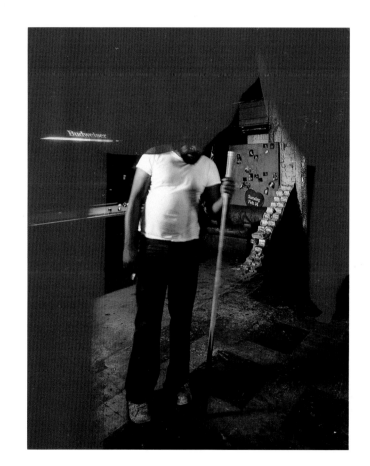

AUTHOR AND ARTIST SERIES

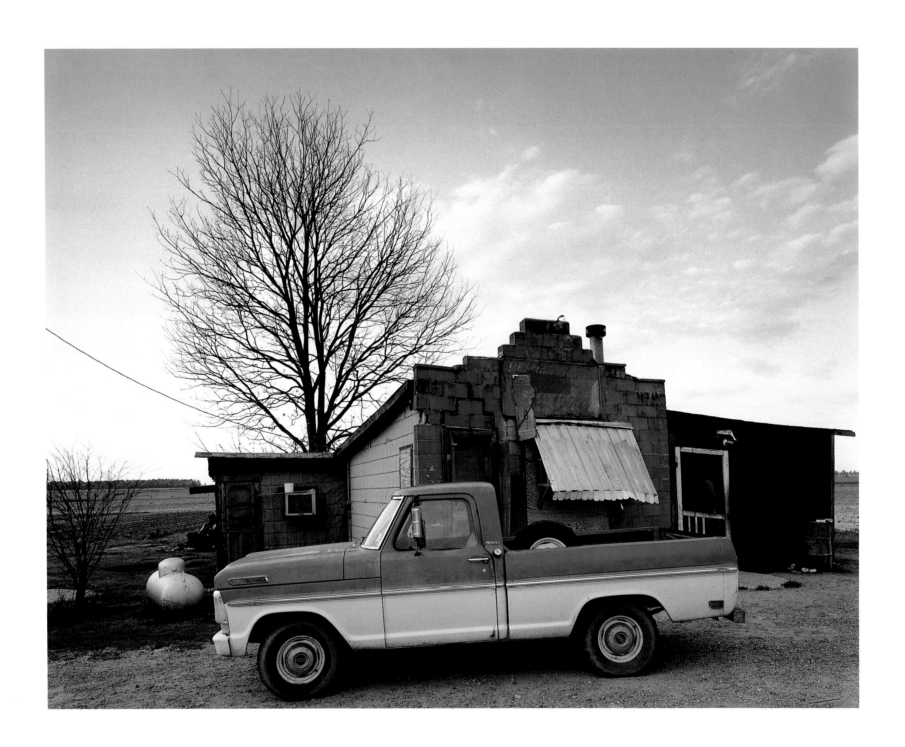

JUKE JOINT

PHOTOGRAPHS

Birney Imes

by Birney Imes

With an introductory essay by Richard Ford

University Press of Mississippi / Jackson and London

Copyright © 1990 by
University Press of Mississippi
Photographs copyright © 1990
by Birney Imes

Second paperback edition, 2002

All photographs were made in Mississippi.

Library of Congress
Cataloging-in-Publication Data

Imes, Birney, 1951-
 Juke joint: photography / by Birney Imes;
 introductory essay by Richard Ford.
 p. cm.—(Author and artist series)
 ISBN 0-87805-437-5 (alk. paper)—
 ISBN 0-87805-440-5 (ltd. ed.)—
 ISBN 0-87805-846-X (pbk.: alk. paper)
 1. Photography, Artistic. 2. Hotels,
taverns, etc.—Mississippi—Mississippi
River Region—Pictorial works. 3. Imes,
Birney, 1951— . I. Title. II. Series.
 TR654.I42 1990 90-30099
 779´.4´092—dc20 CIP

British Library Cataloging-in-Publication
data available

Designed by John A. Langston
Printed in China by Dai Nippon
(America), LLC

Photographs on the opening pages: Leland
Juke, Leland, 1983 (page 1); Bailey's Late
Nite Spot, Rolling Fork, 1984 (frontis-
piece); Ferry Club, Lowndes County,
1989 (this page); The Black Gold Club,
Durant, 1989 (page 8).

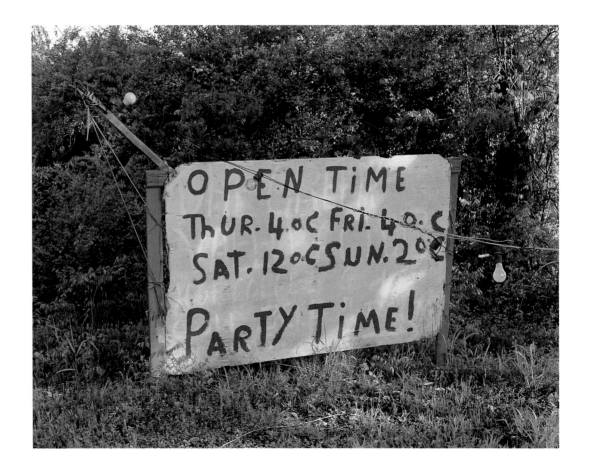

FOR LIZZIE

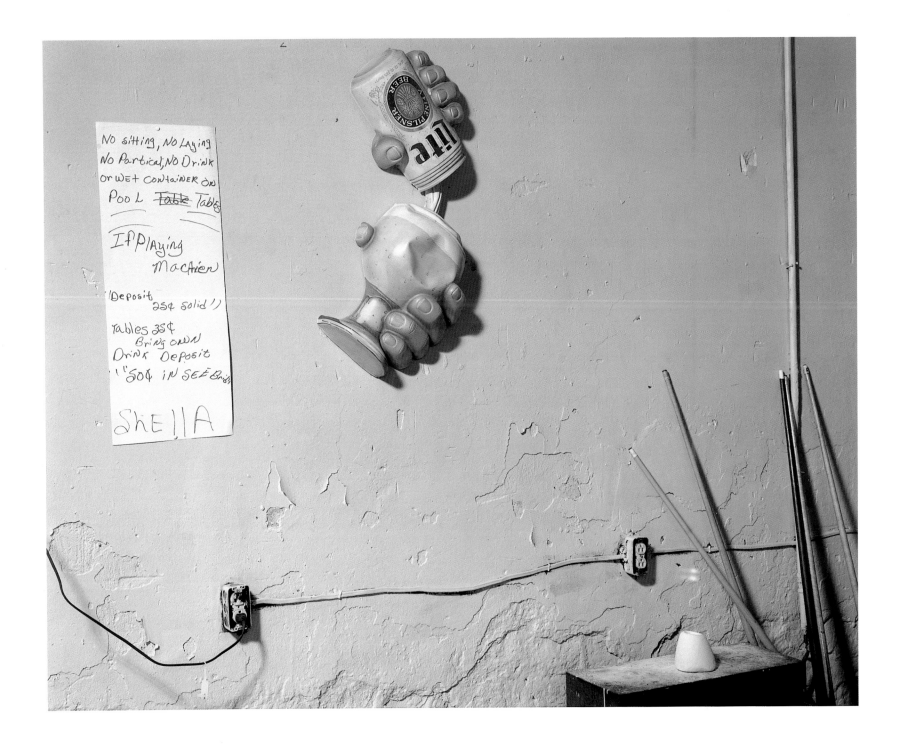

INTRODUCTION

As with most of us, I am not a special friend of art which requires explanation. An hour in a public place with a Calder mobile usually suits me better than an afternoon in the stacks with Joyce (James). I remember when I read "The Waste Land" in college, my professor insisted I buy three other books just to help me read that first one. And I couldn't do it. Far from understanding the poem, I did, however dimly, like it. I suppose the scholarly way to learn must've seemed too round-about for my first purposes. Possibly this is my hook into photography. Because, for all its "retinal realities," its complicated authorship and fidgety reliance on delicate machinery, at its best a photograph is sleek and self-sufficing in its relationship with us. It doesn't require words to be itself. It is art and does not renounce complexity, but by and large it is also what it simply seems to be when we look at it—an honest medium, as Edward Weston said about it. And in us it inspires the flattering faith that our direct, most human response is probably a true one.

There is a story Birney Imes tells about a friend who suggested that none of the subjects in his photographs—these shadowed, motley rooms with honky-tonk facades, the oddly objectified humans who stare at us—none of these ever actually existed on the earth but were actually creations of Imes's imagination—only *seemed* to be juke joints with men sleeping it off and women smiling out from boozy luminence. All of it was only a treat for the eye. An illusion. It is a story that makes Mr. Imes laugh.

Still, tracing Imes's photographs back to life may not be so amusingly simple, since very little in them makes me think: yes, life's just like that. *Life's* usually not this pretty; its colors are hardly ever this substantial, this bright and chosen. Life isn't framed. It lacks "ghosts." The old and disappearing do not seem so suddenly new. Life's lighted differently.

In fact, I'm sure if I motored up to Itta Bena or to Alligator, to Sledge or to Falcon—remnant Delta towns where many of Imes's photographs were made, I would scarcely find what I find in his photographs. Instead I'd see life in context, life as I know it everywhere—pale, hesitant, less noticeable, the light more diffuse, human activity less fixed, more open to speculation.

Mississippians, of course, may find this an over-dainty distinction—real life distinguished from life *treated* by art. They have acquaintance on their side, after all, and know perfectly well that to see what the Delta is really like one would almost certainly need to take that

trip to Falcon or Itta Bena. Indeed the very prettiness of Imes's photographs, the extra-ordinariness of their subjects, their benignity and aversion to irony—all these may make a certain neighborly recognition of his pictures irresistible. We may feel we know precisely what's just beyond each frame, how the still air feels out of doors, what everybody's name is, how everything smells, who's apt to come walking in that screen door next. We might even feel these photographs (like "The Waste Land") are *meaningful,* that they annotate a secret stratum of real life, or interpret a special human psychology. Volumes may seem to speak from single exposures.

We're lucky, of course, when art beckons to us, no matter how. And if we're fated to connect what we understand of palpable Mississippi life with the complex experience of these photographs, we're free to. Mr. Imes probably wouldn't fight us over it. A bond between place and photograph does exist. And even if I feel that Mississippi is not the essential matter of these photographs, and conceivably only their objective whereabouts, it's still true that what we like about the pictures fortifies how we feel about the place—its people, its rooms, its glimpsed green fields with trees in the distance. There is a Mississippi out there. Once it looked like this, and we like it.

Yet, I'd sooner pass over this view of Imes's photographs which has them act as social documents or as picture-postcard-art extraordinaire or as story-telling cue cards. These

readings deflect my interest away from the obvious. Nothing much tempts my interest out of the frames; no stories are told to me except ones I'd need to make up on my own. And I don't care to go to these places, don't much feel beckoned. (I've been there already, and they weren't that glamorous.) Nothing finally seems explained, nothing interpreted—simply acknowledged: here is a blue-fronted building, a blue truck, blue sky at a high distance, an as-yet leafless tree, fields on either side. Look at it. Meaning, a concise social bottle-message, isn't really the point, even though life's the subject—its clear residences, colorations and contingencies—illumined and shaped by the photographer's vision. What we see inside each frame may possess a corroborative moral dimension, but if so its artistic idiom is a more frank one: truth through the luxury of beauty.

To me, all photographs are part magic. Like most amateurs, I can never believe that what a photograph contains is exactly what the photographer has seen in advance with only his eyes. How could he anticipate, plan, control so much? Rather, a photograph represents to me a *use* made of what's been seen, a combining of things observed, with the effects of light, the capabilities of a camera, the confidence of a plan, all fused with some ingredient of the moment, the unexpected and adventitious, which is a source of much art, even slow-going ones like writing novels. This, indeed, is what we sometimes respectfully think of as imagination—the pur-

poseful, felicitous use we make of the unknown. Keats wrote of Byron: "He describes what he sees—I describe what I imagine. Mine is the hardest task."

So appealing in Imes's photographs is the sensation created in us that we are here being shown, are even intruding upon attitudes of face, dispositions of furniture within rooms, eventful effects of light and the placement of buildings on a landscape—that have not been shown before and that may be secret, previously forbidden to us, even though we may have stood in these very rooms and roads once and believed we knew them intimately. The unknown—some quality residing in the chosen subjects, but also in the intense, caressing efforts to photograph them—this unknown seems to have been put to use.

To some extent we can account for what's exotic or seems exotic, and take pleasure in doing so. Partly it originates in the abstracting quality of *all* photographs, detaching, as they do, the ordinary from the rational pinch of its surroundings, its spatial logic, leaving life looking weird. We see these rooms and their inhabitants in Imes's photos as we would see them in a mirror angled to conceal us in its reflection though we sense we are in it. A dead tree grows up through an empty table top; an old man stares inwards from the frame's edge—at what we're not sure; red window dressing ornaments a wall with no window. So much of what we like in the world we like in context; yet we're relieved and our notice sharpened when

context recedes. The familiar turns strange, turns familiar again; and with every spanning of the gap we register a heightened "poetic reality," which is to say, heightened pleasure.

Though partly, too (and I need to account for this somehow, don't I?) the exotic *I* feel arises not surprisingly from the fact that I am white and everything—people, culture, ambience, the stake in life itself—*everything* within each frame is black. I would like to make less of this distinction if I could, since my appreciation for these pictures rests on their capacity to subordinate their subjects, to be other than cultural snapshots; and since I like the maxim which says photographs are not meant inevitably to lead us back to factual beginnings, but on toward something uniquely photographic in character. Ultimately I believe—naively and democratically—that anyone, white or black, will sense the same thrilling otherness I sense in these pictures and will like them more for it.

And last, their authority, their permanent character of having trapped something strange-in-life originates in Imes's own persistent, repetitive attention to the out-of-the-way ordinariness of his subjects—a singular and intense persistence which promotes singularity and intensity as features of artistic importance. It's not true that anything finally becomes interesting if we only look at it long enough. (Plenty in life becomes much more boring, and photographs only stoically bear it out.) But it is the photographer's privilege to challenge our interest with his own special kind. And in this case the pay-off has been rich.

To an extent, of course, such intensity and persistence is self-referring. Grouped in

these pages, Imes's photographs take on a certain un-innocent and accumulating confidence regarding their own effects, a feature which is not bothersome but actually relieving. And if one of their important effects is that by texture and technique they portray a visual surface on which buildings, rooms, signs and people signify almost equally, and if as viewers we feel vaguely disengaged though not disaffected from the human life exposed, our insecurity is lessened by the promise that we have the assent of the photographer, whose compositions and strategies of light and drama and emphasis and film speed and color these are. This, we think, is the way he wants us to feel. Perhaps this is the way he feels.

To go on in this way, of course, threatens to embroil these photographs in artsy modernism and overlook their clearest appeal, one we ought to feel free to answer. Sweet longing drifts through these pictures like heat, and words do not even describe it so well that we much wish for them. These staring men and staring women, these droll colors and signs which speak playfully to ghosts, to shadows in doorways, to half-abandoned honky-tonk rooms— these do not animate so much as punctuate the provisional character of a small life glimpsed and briefly desired. Here, only objects have permanence but seem to share it sympathetically. Human speculation is at a minimum. What we see in Imes's photographs does not equal the human condition, only *a* human condition, a miniature advanced as art and meant to ease the adjustments between ourselves and the world by offering beauty, consolation, diversion, the satisfactions of direct address—all the usual enticements by which art dignifies and pleases us.

Something feels hidden in these brightly-wondrous photos, but nothing is. Ghosts whose presence we can explain make us feel some important secret lies in reality, and that if only we would look longer and more judiciously we would find out more about it. But when is that not ever so? Nothing tells us we've been mistaken about the world here; the familiar is simply braced by a fabric-feeling of the new. And conceivably we look with urgent interest because we sense we might just as easily be indifferent. And by that appeal—an appeal familiar enough to any art—excellence and value are given an occasion. Birney Imes has noted that many of these buildings are gone now, moved out by time or by someone's timely idea, so that his photographs have become their only records. One day—in not so long a time, maybe— they may all seem to us as they seemed to Imes's friend, as unearthly things, as pure gestures of the photographer's imagination.

Richard Ford

December, 1989

JUKE JOINT

1

The Pink Pony Cafe, Darling, 1985

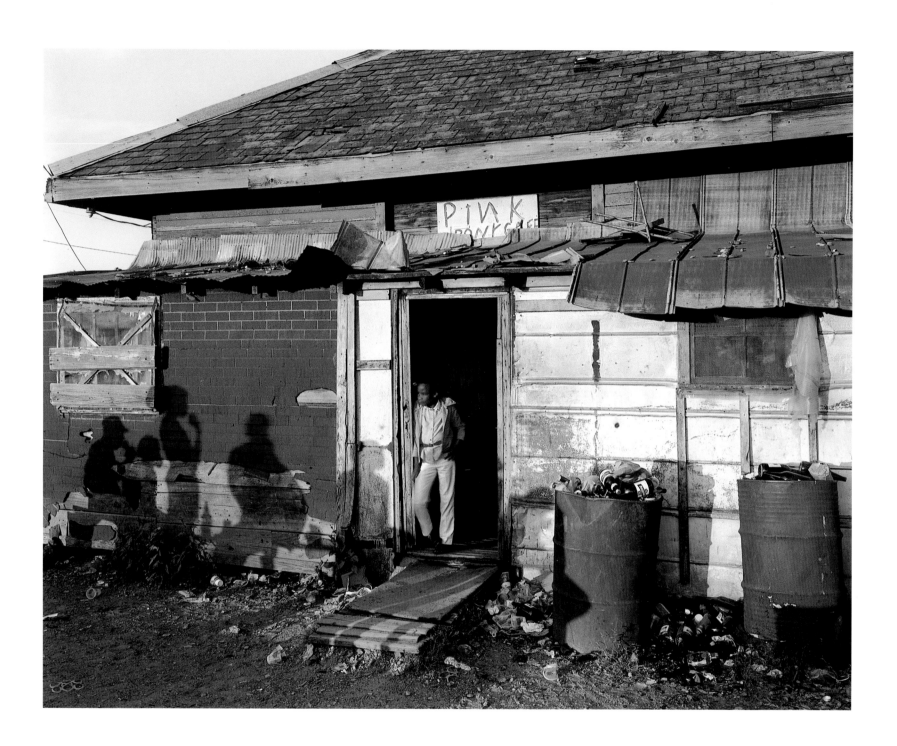

2

The Pink Pony Cafe, Darling, 1983

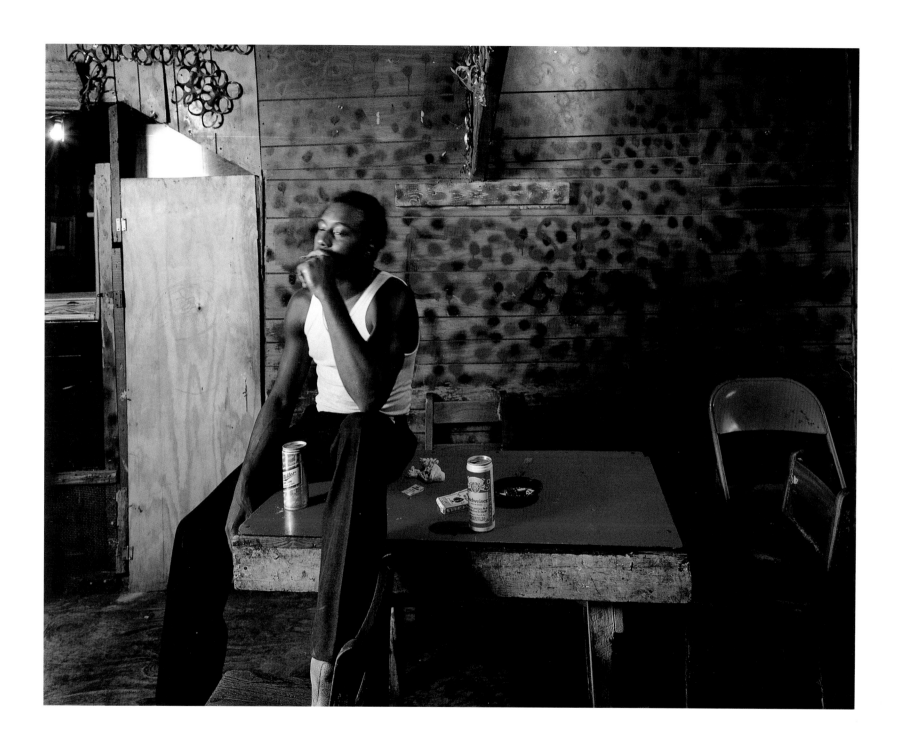

3

Riverside Lounge, Shaw, 1985

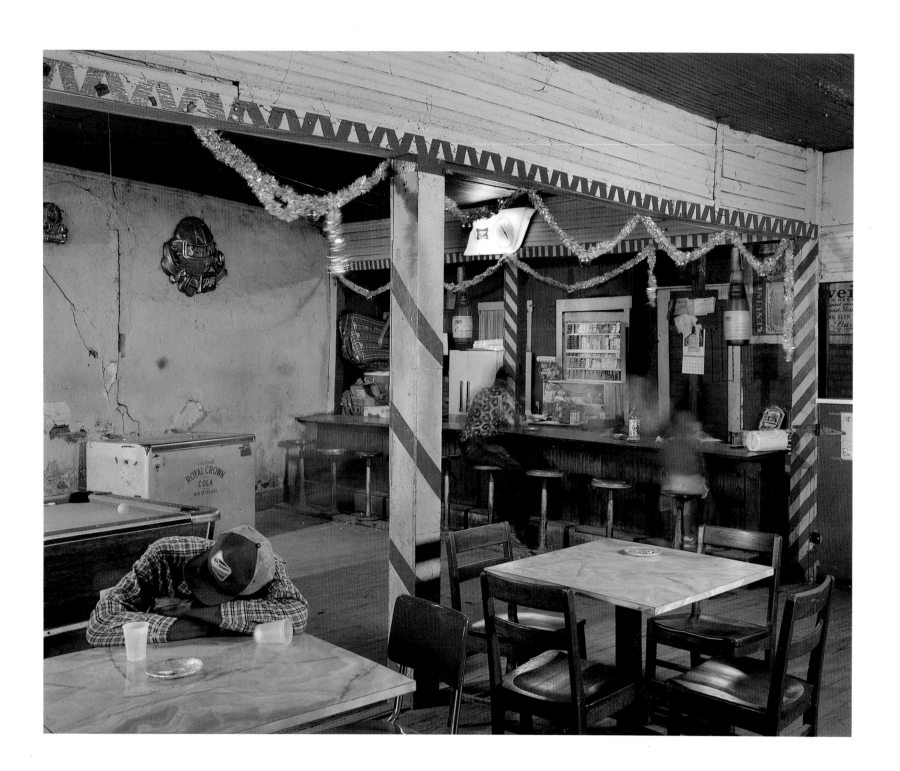

4

Riverside Lounge, Shaw, 1989

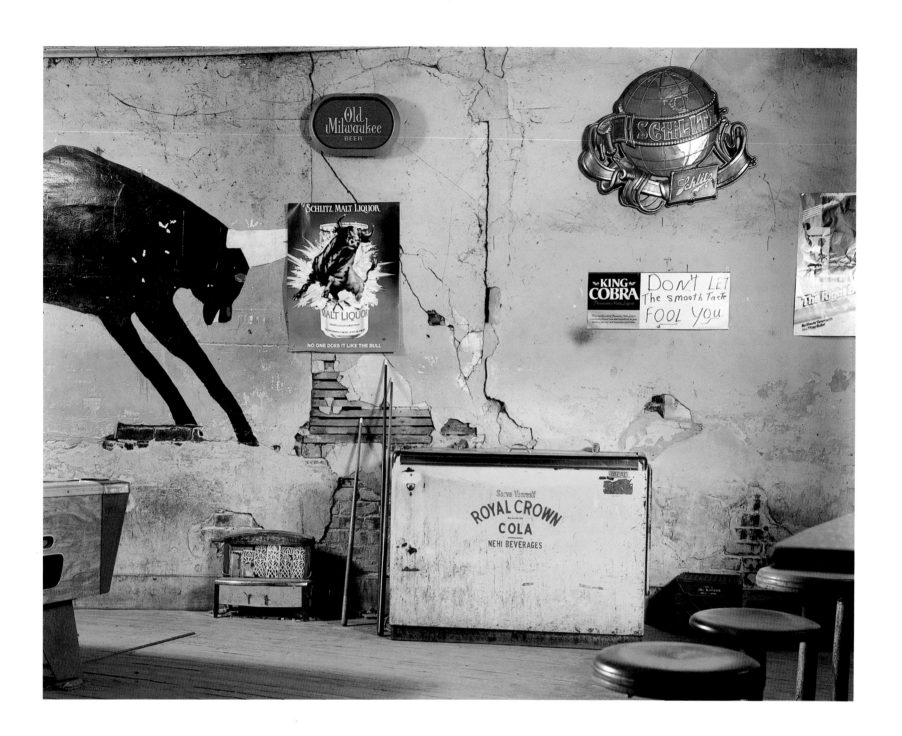

5

Riverside Lounge, Shaw, 1986

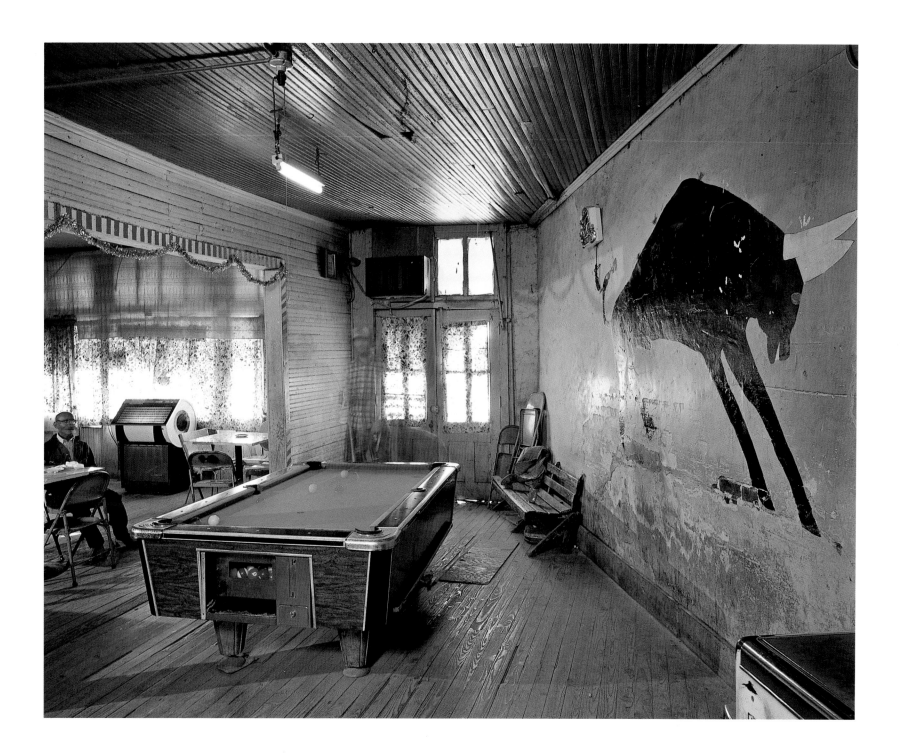

6

Riverside Lounge, Shaw, 1984

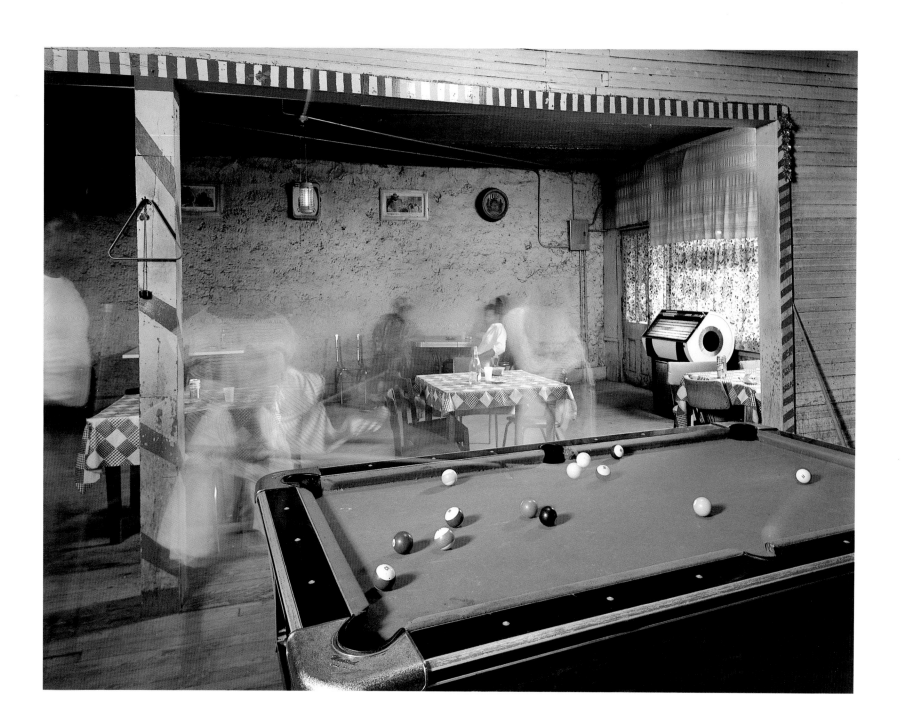

7

Leland Juke, Leland, 1983

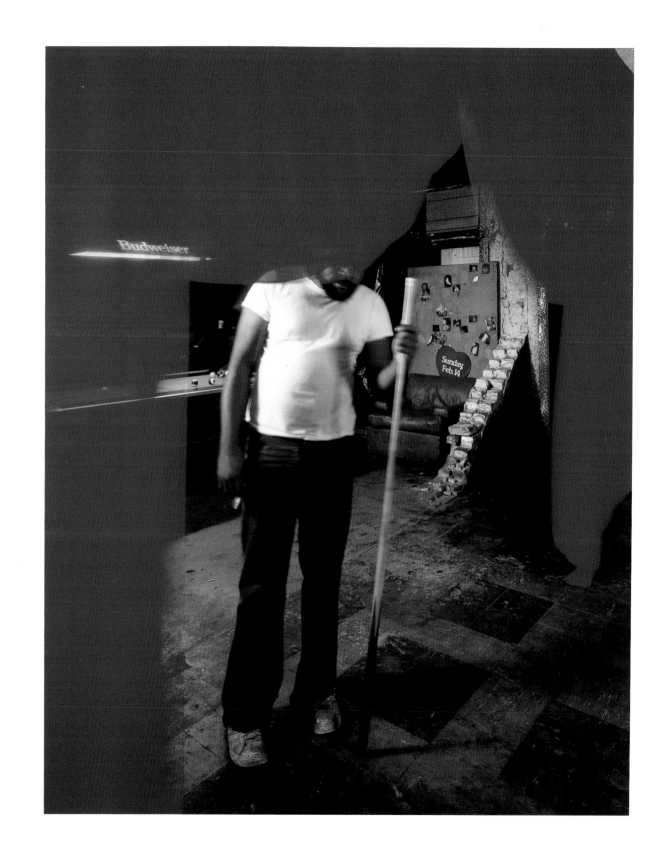

8

The Busy Bee Cafe, Hollandale, 1985

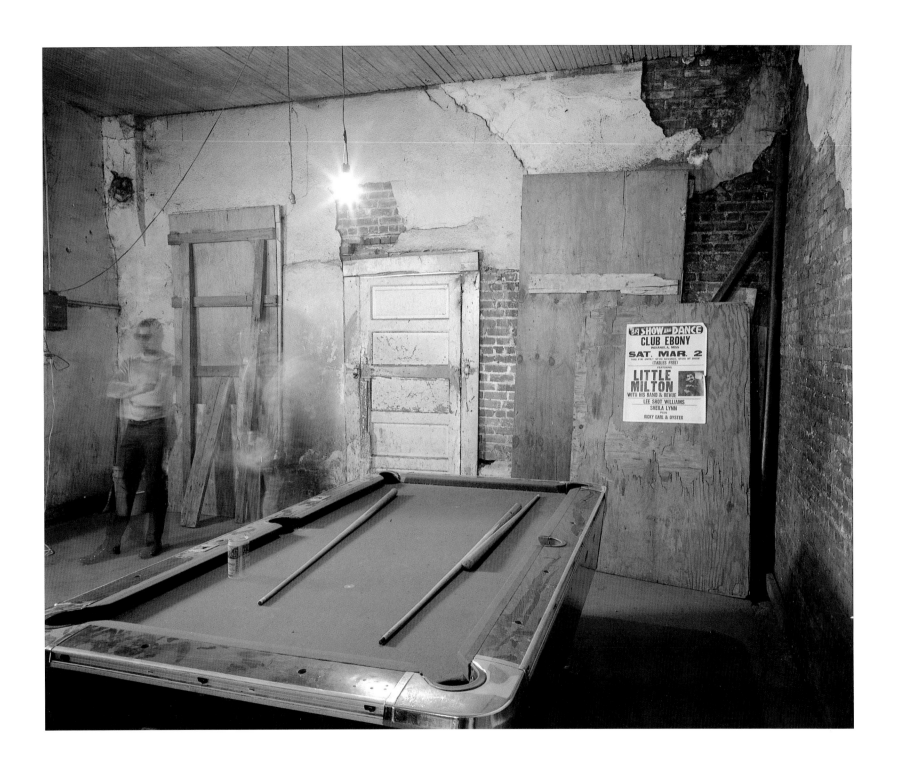

9

Booba Burns' Place, Greenville, 1988

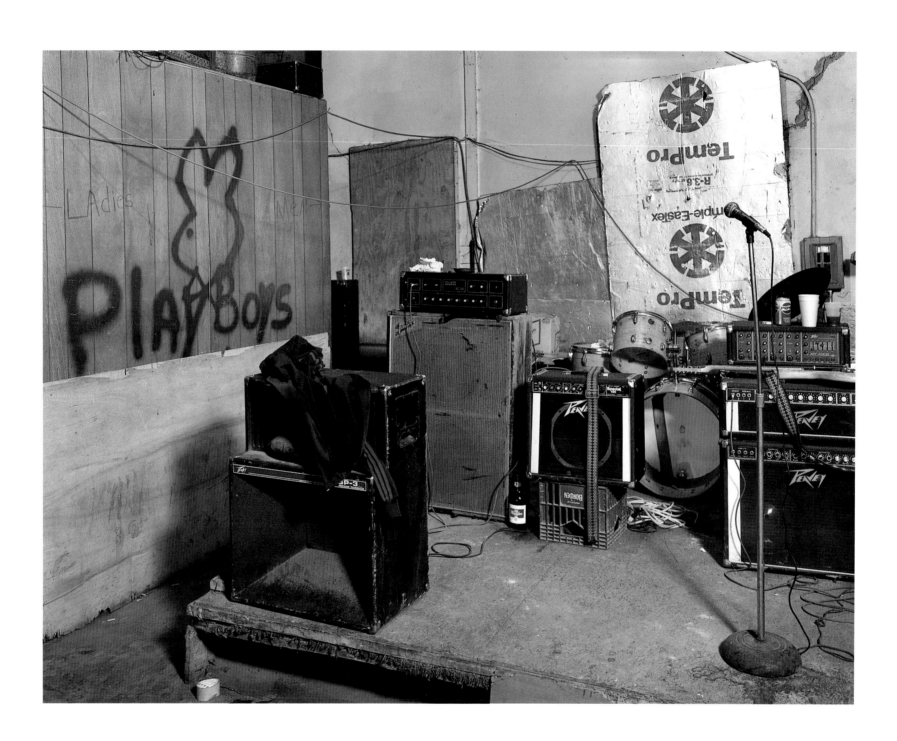

10

The Playboy Club, No. 2, Louise, 1983

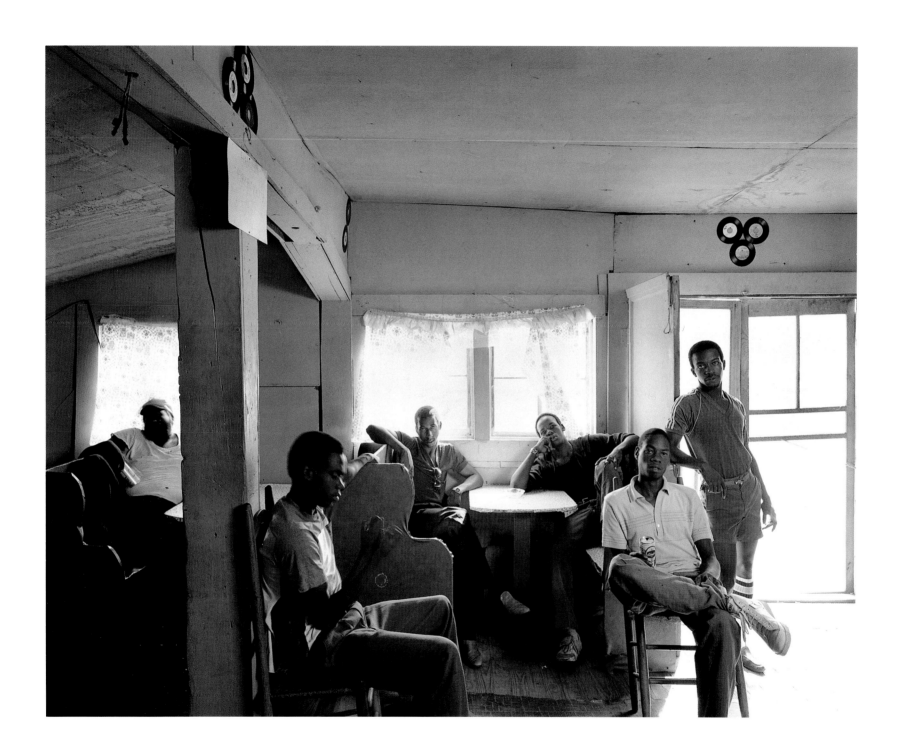

11

Demar's Place, Clarksdale, 1983

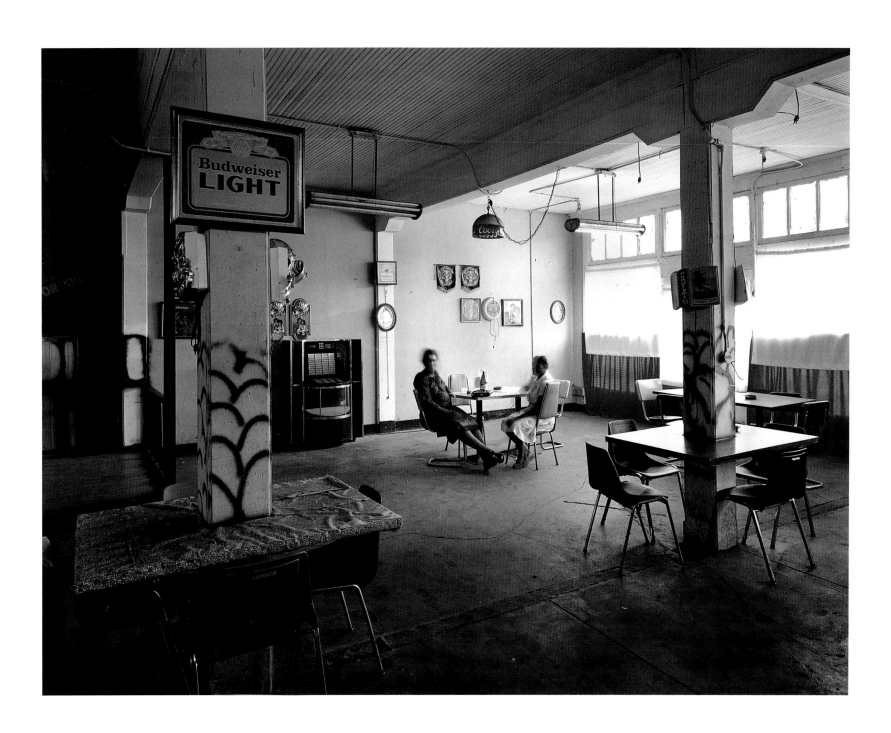

12

The Uptight Cafe, Moorhead, 1984

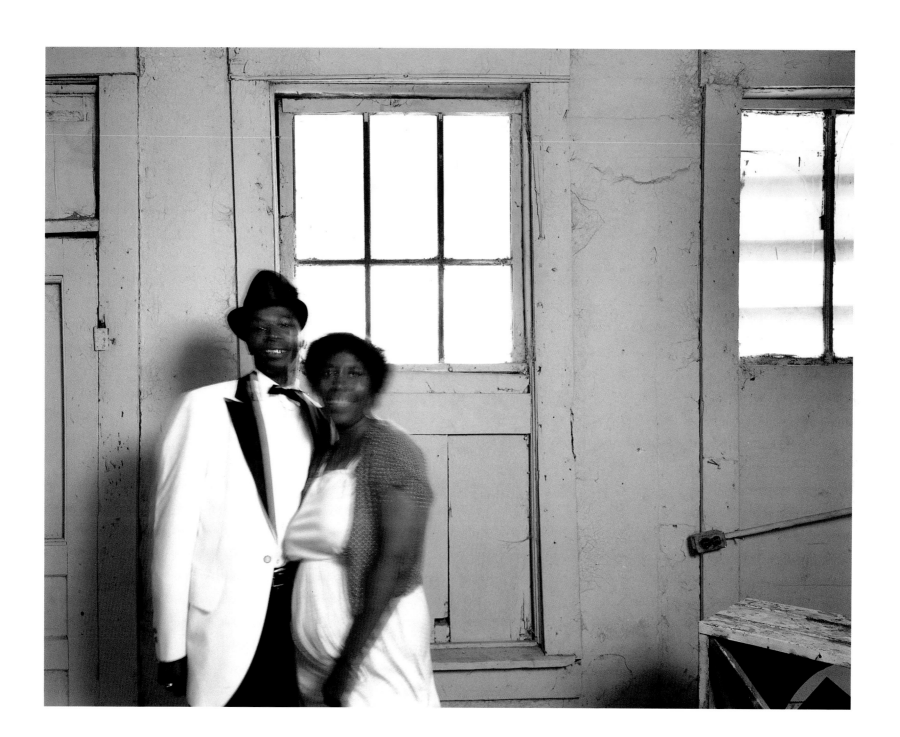

13

Turner's Grill, Clarksdale, 1983

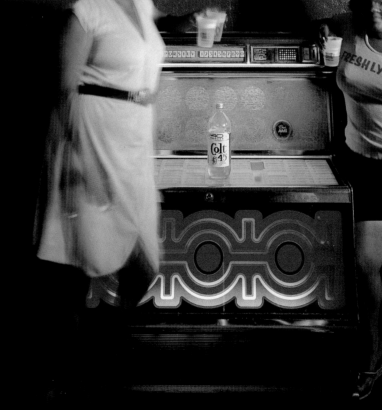

14

The Royal Crown Cafe, Boyle, 1983

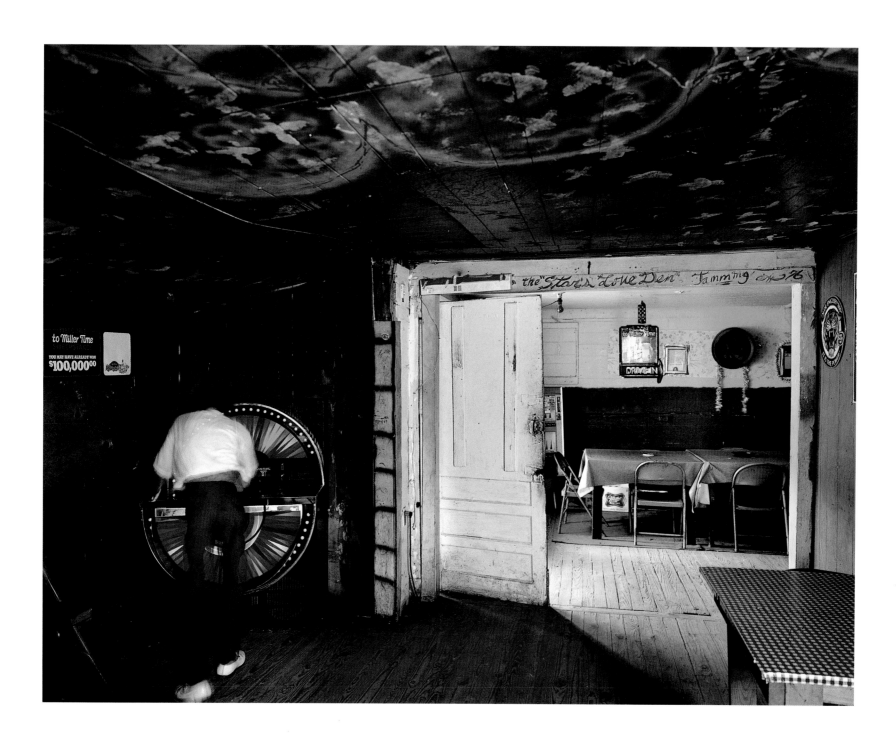

15

The Rock and Roll Cafe, Cleveland, 1989

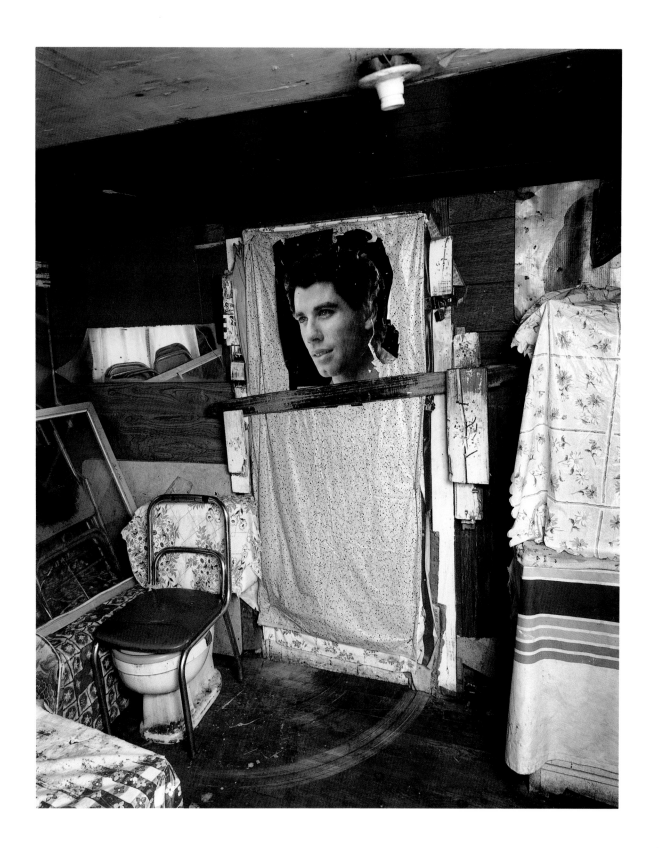

16

The Skin Man Place, Belzoni, 1986

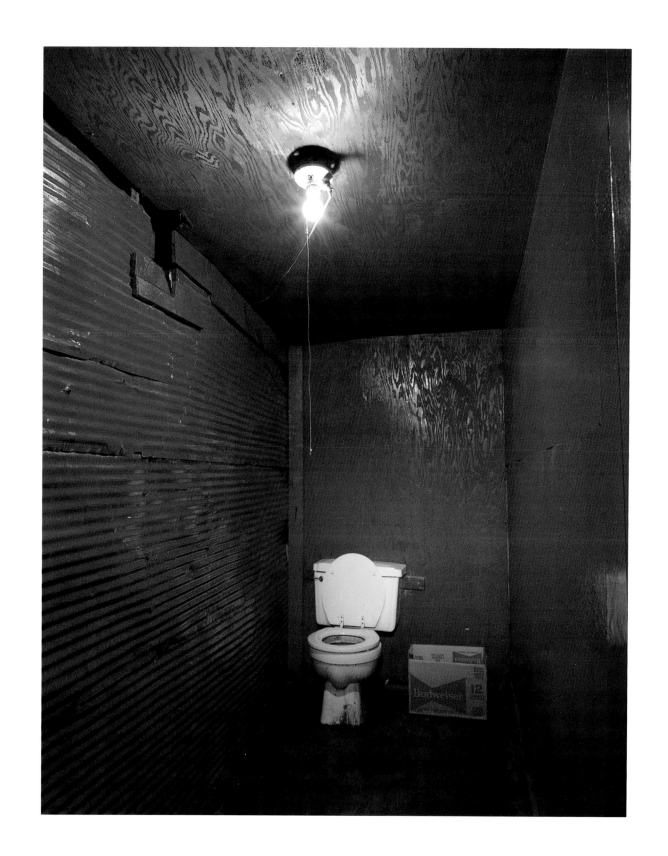

17

The Social Inn, Gunnison, 1989

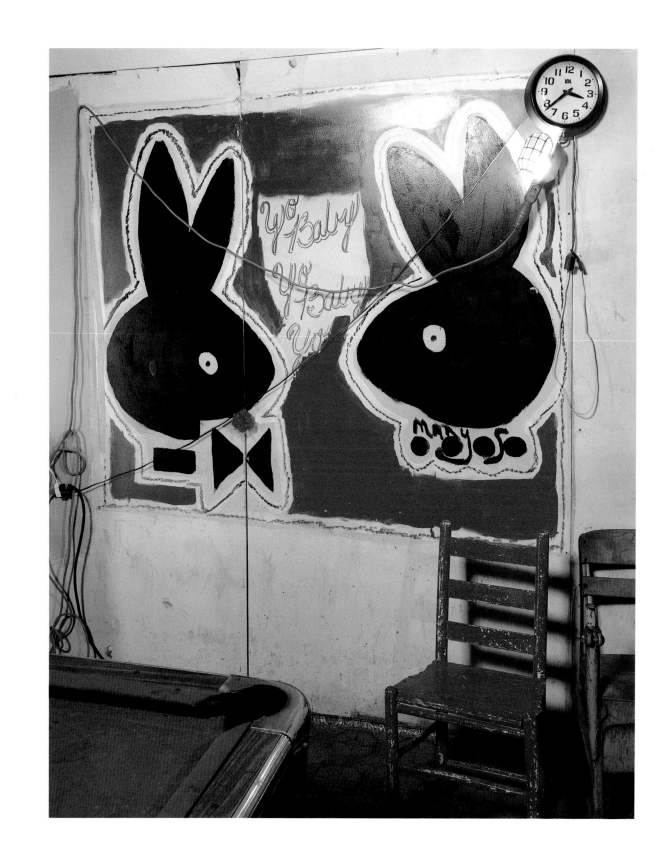

18

Percy Walker's Cafe, Schlater, 1989

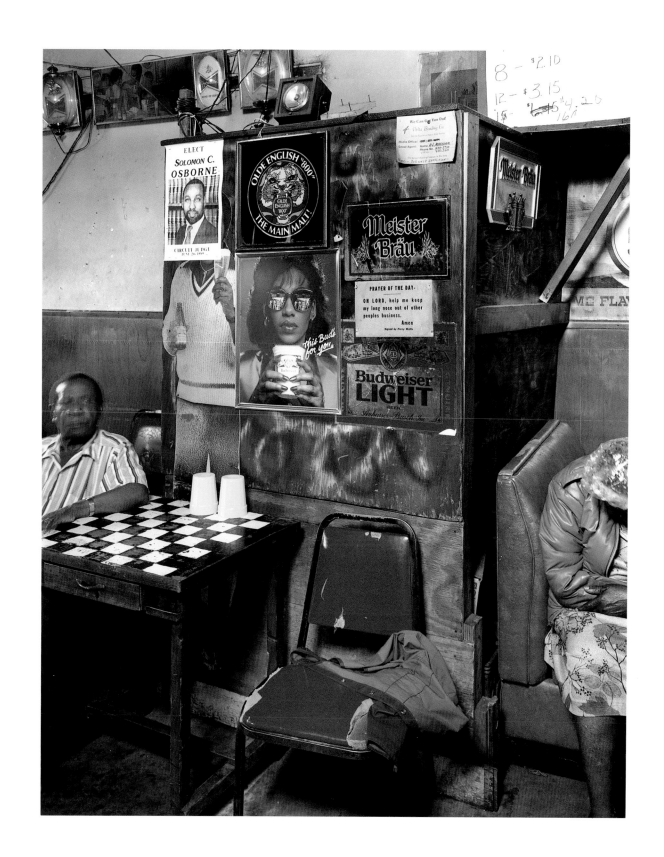

19

Emma Byrd's Place, Marcella, 1989

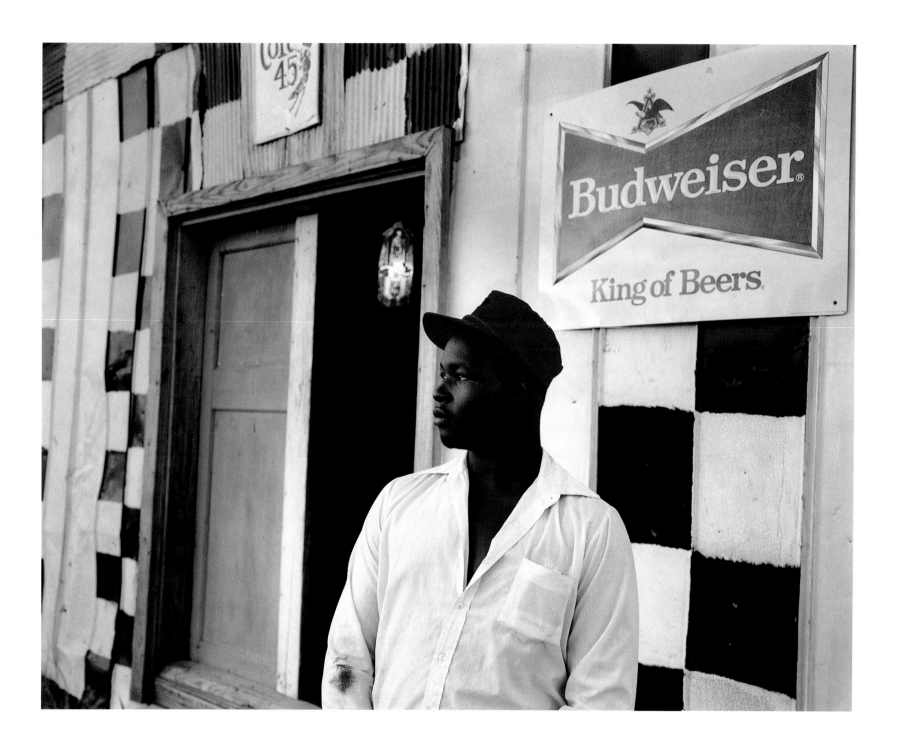

20

Shorty's Place, Artesia, 1988

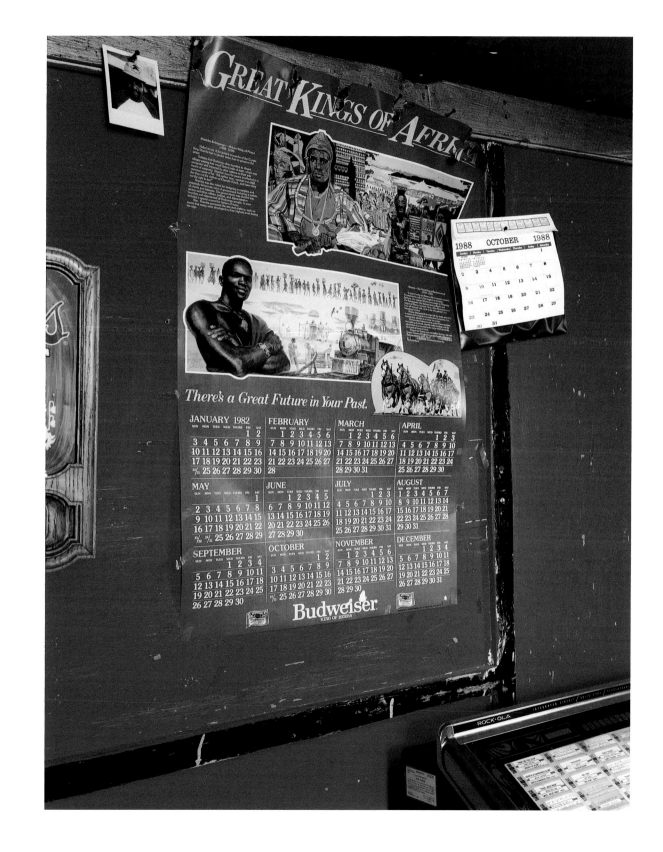

21

Bailey's Place, Yazoo City, 1989

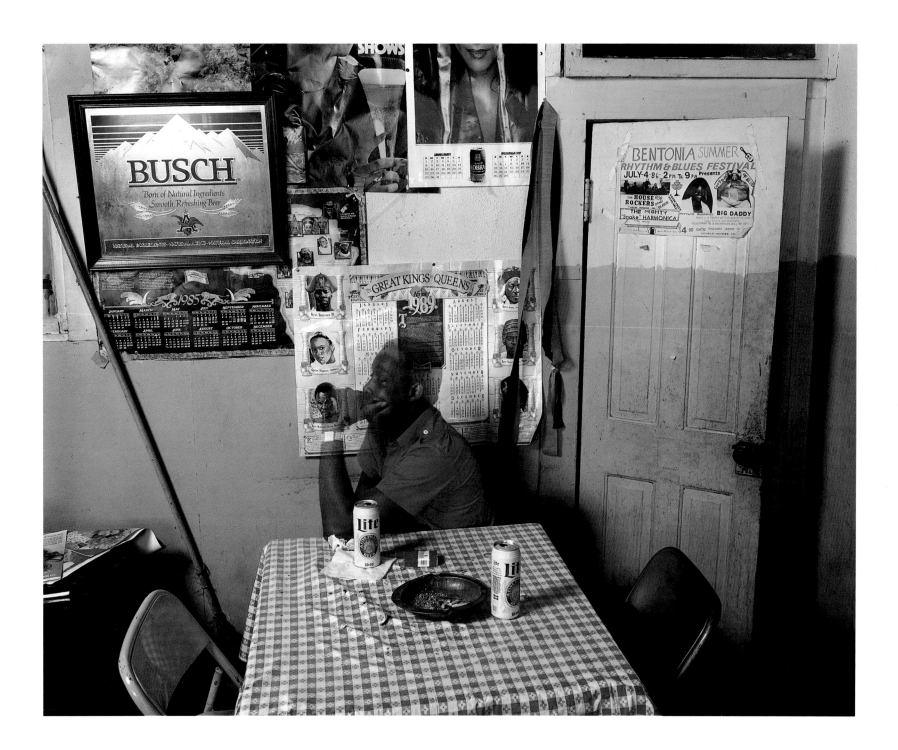

22

The Out of Sight Club, Yazoo City, 1989

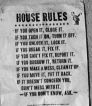

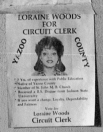

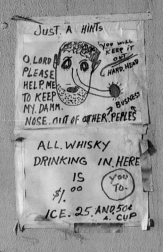

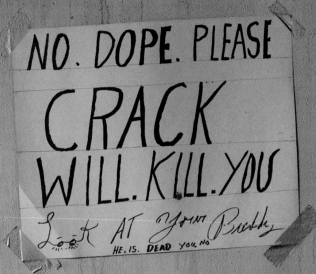

23

The Playboy Club, Louise, 1983

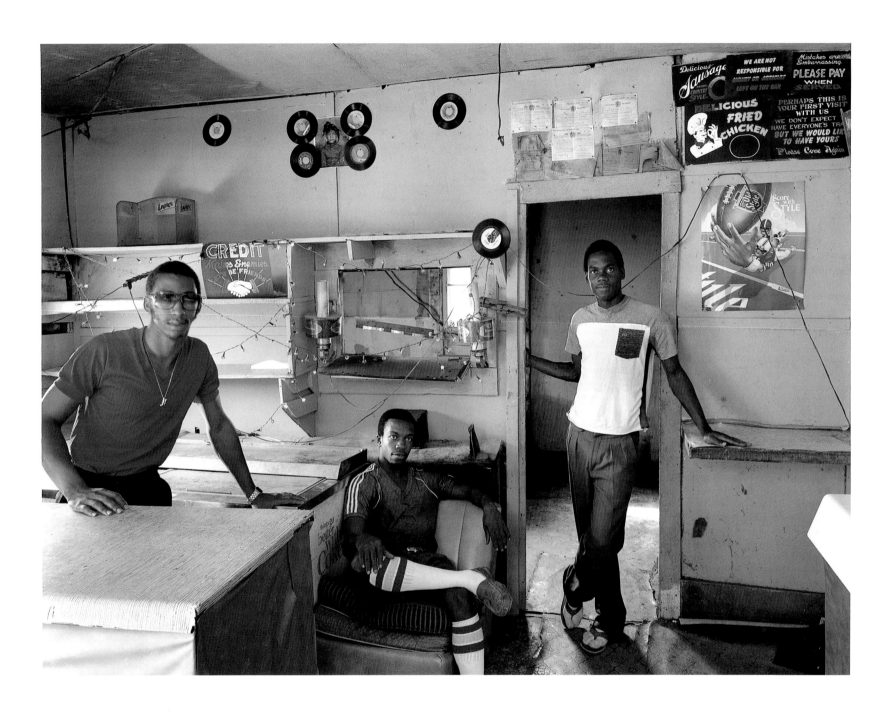

24

Freedom Village Juke, Washington County, 1985

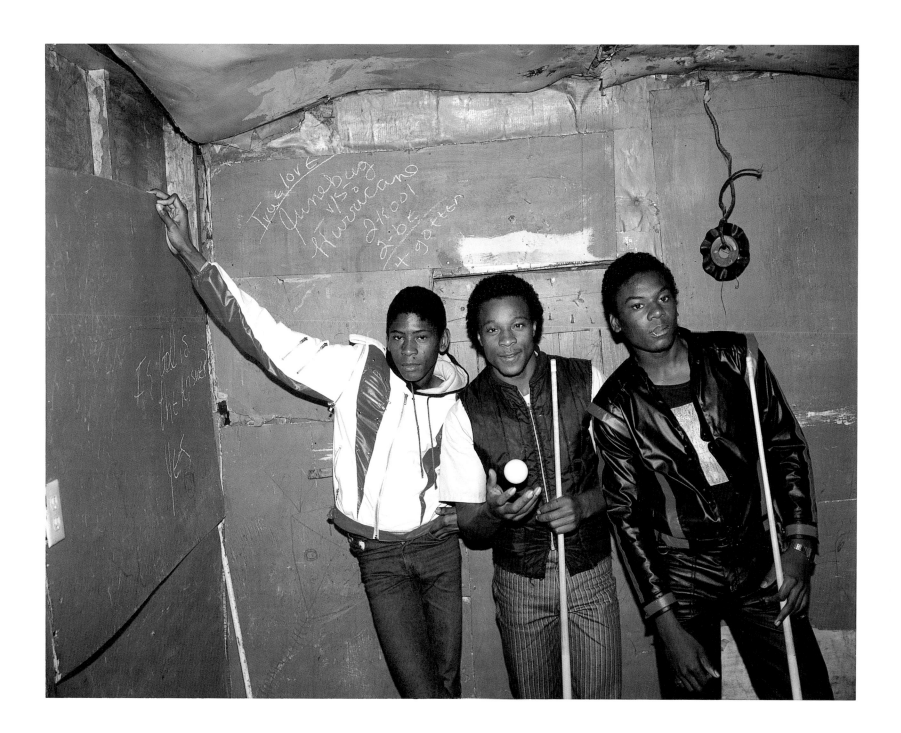

25

Freedom Village Juke, Washington County, 1985

26, 27 (o v e r l e a f)

The King Club, Glendora, 1984

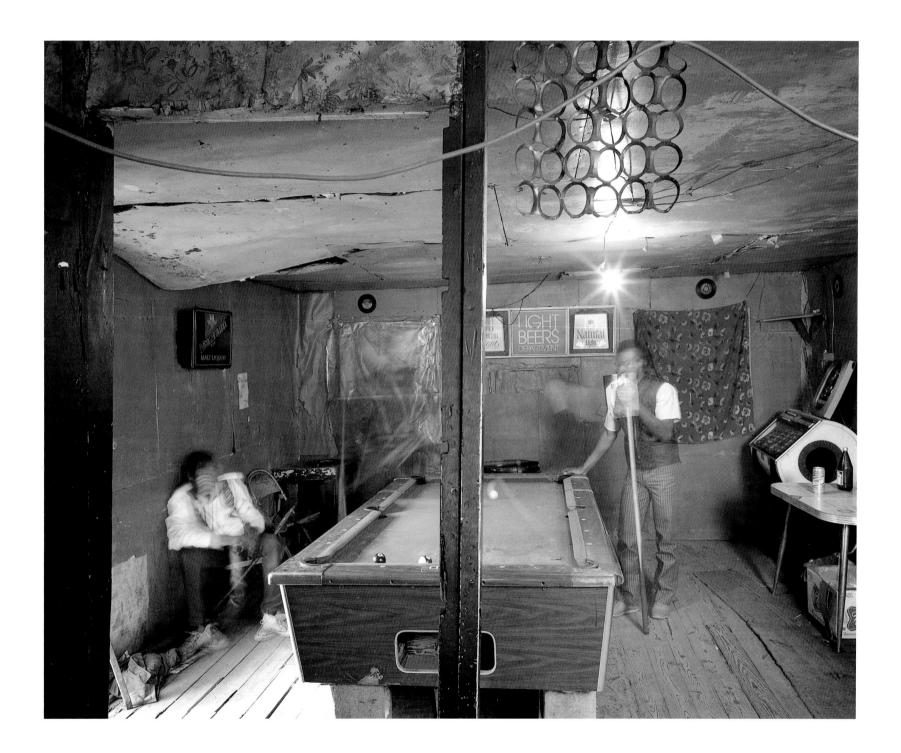

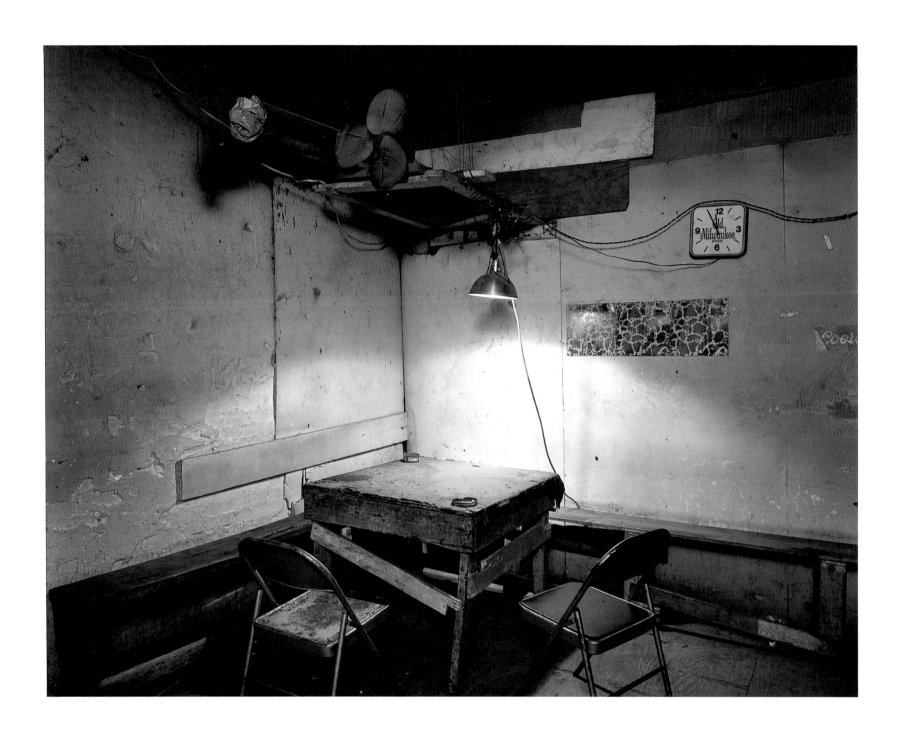

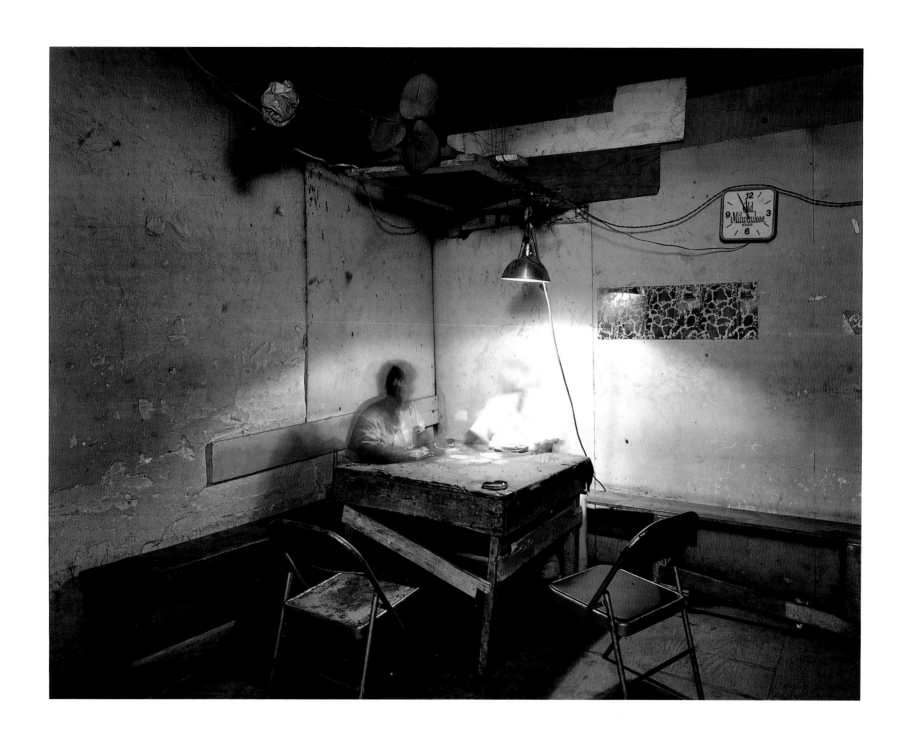

28

The Pink Pony Cafe, Darling, 1983

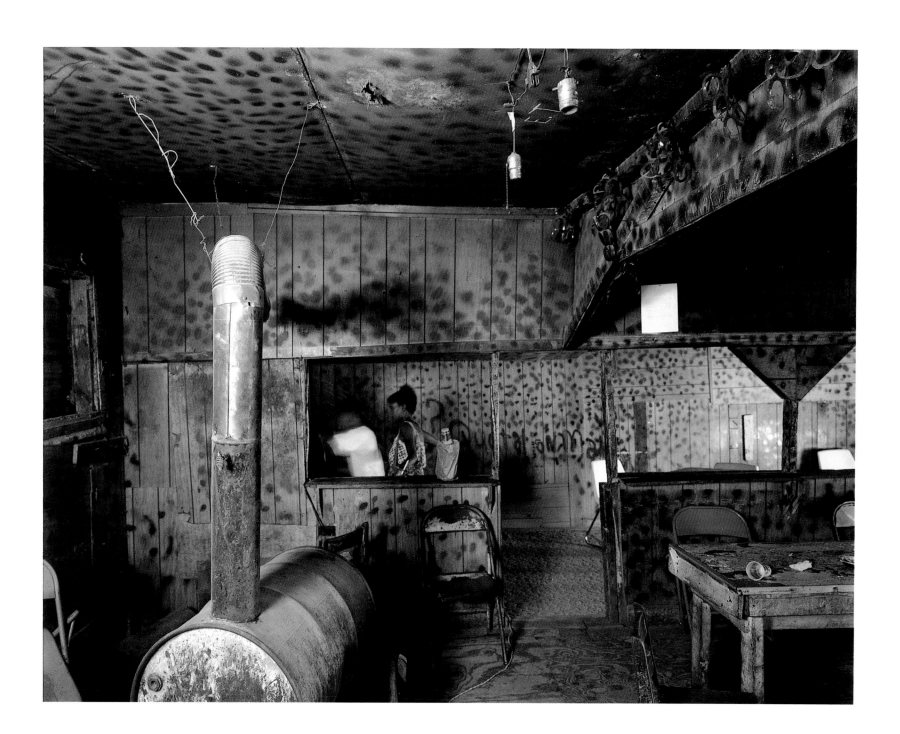

29

The L & N Cafe, Clay County, 1988

30, 31 (overleaf)

Blue Lite Disco, Rosedale, 1983

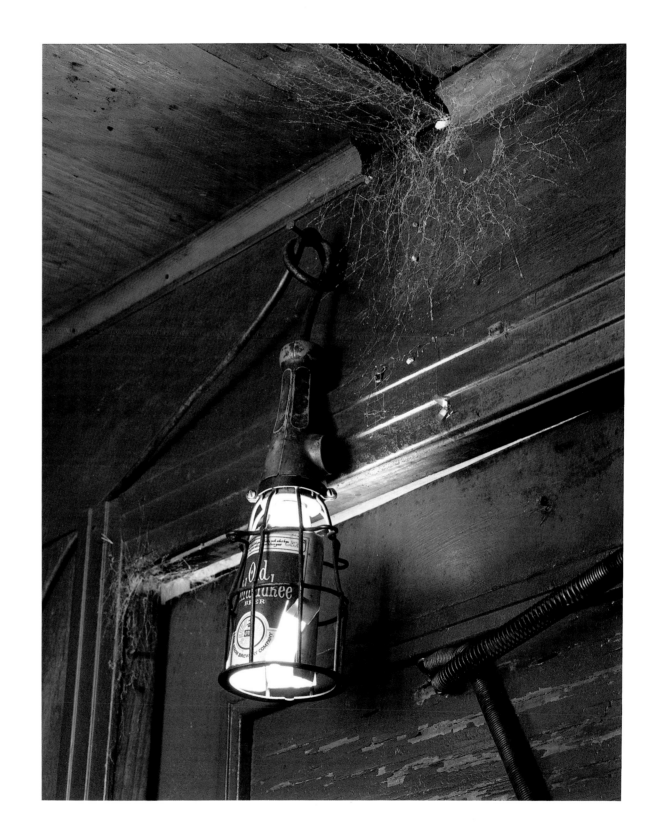

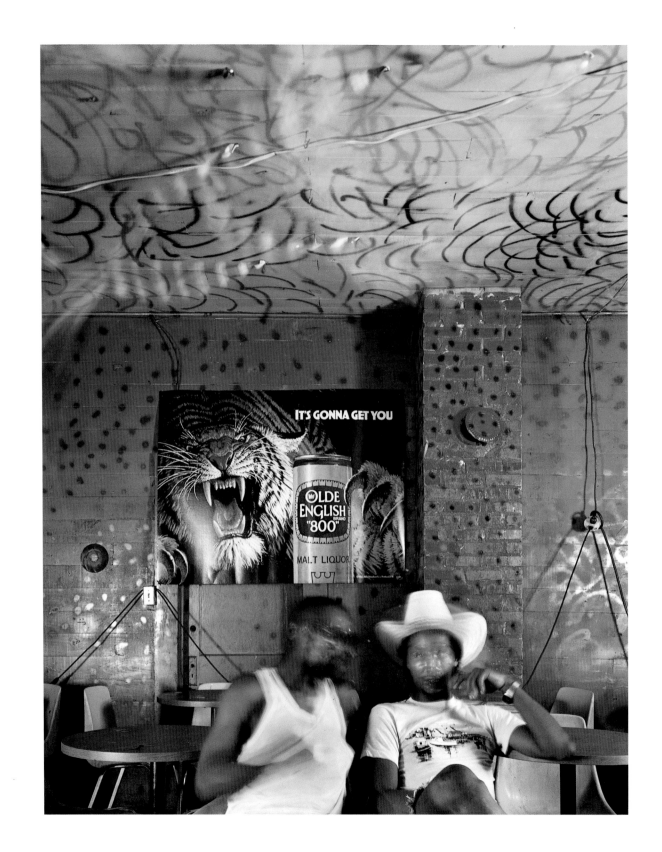

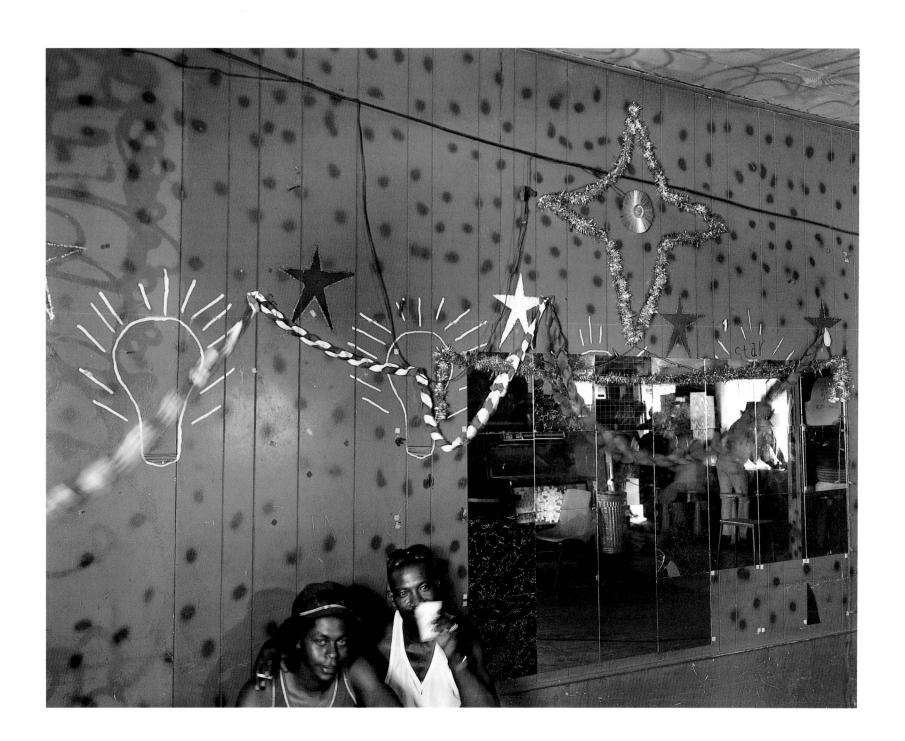

32

The People's Choice Cafe, Leland, 1983

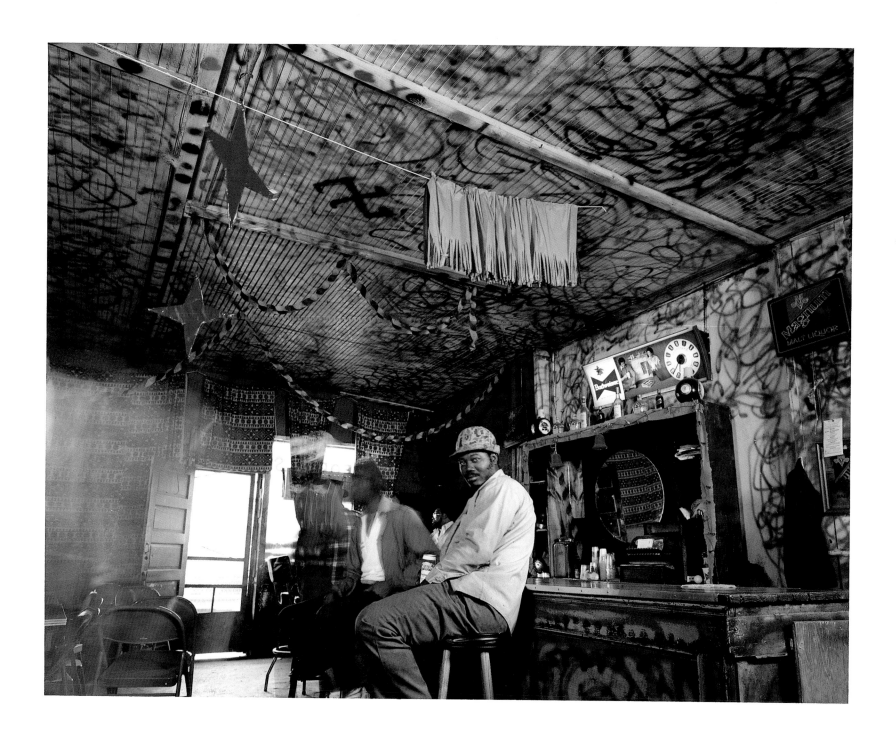

33

Bell's Place, Yazoo City, 1984

34, 35 (overleaf)

The Magic Star, Falcon, 1984

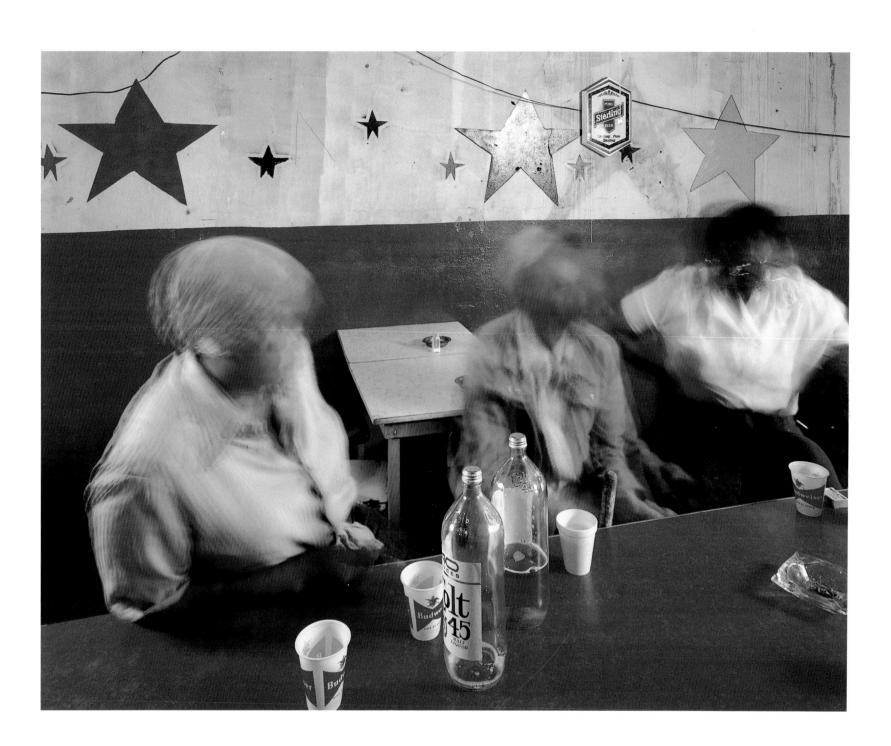

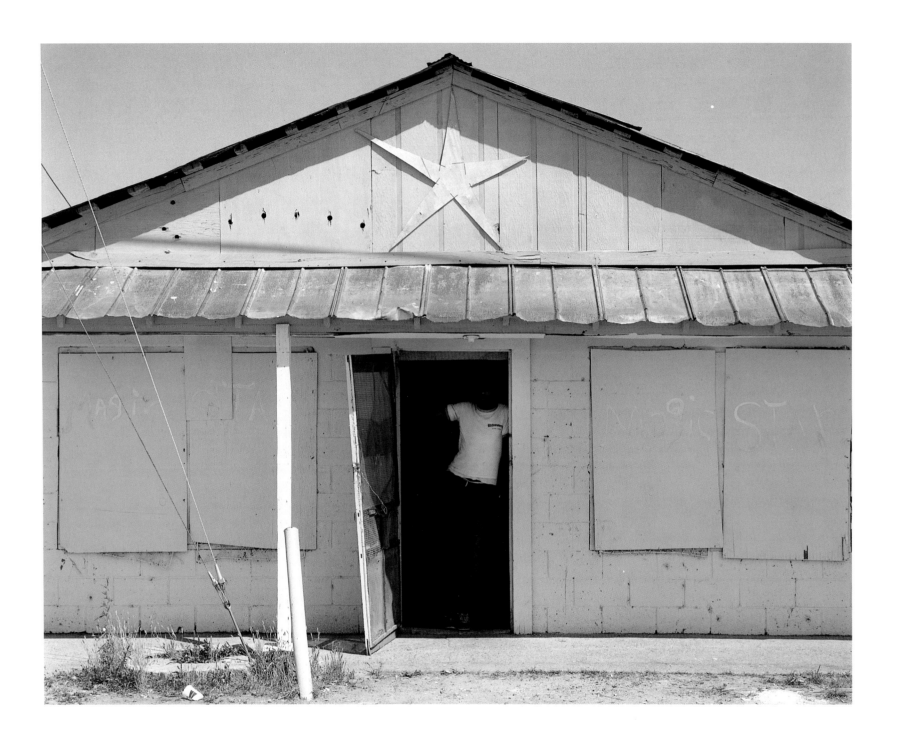

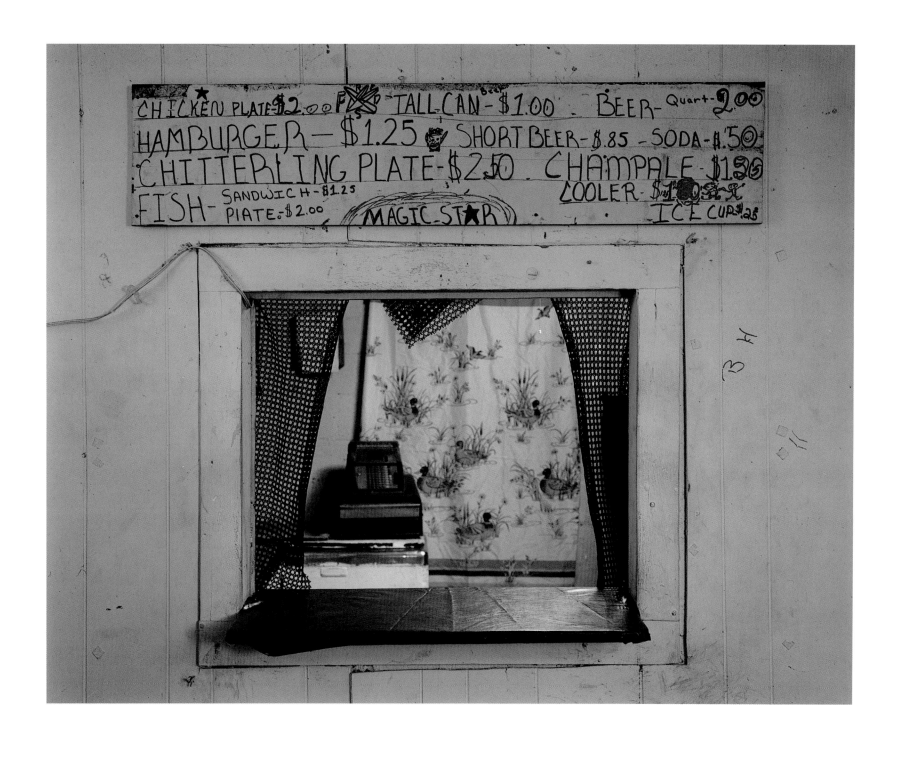

36

Evening Star Lounge, Falcon, 1984

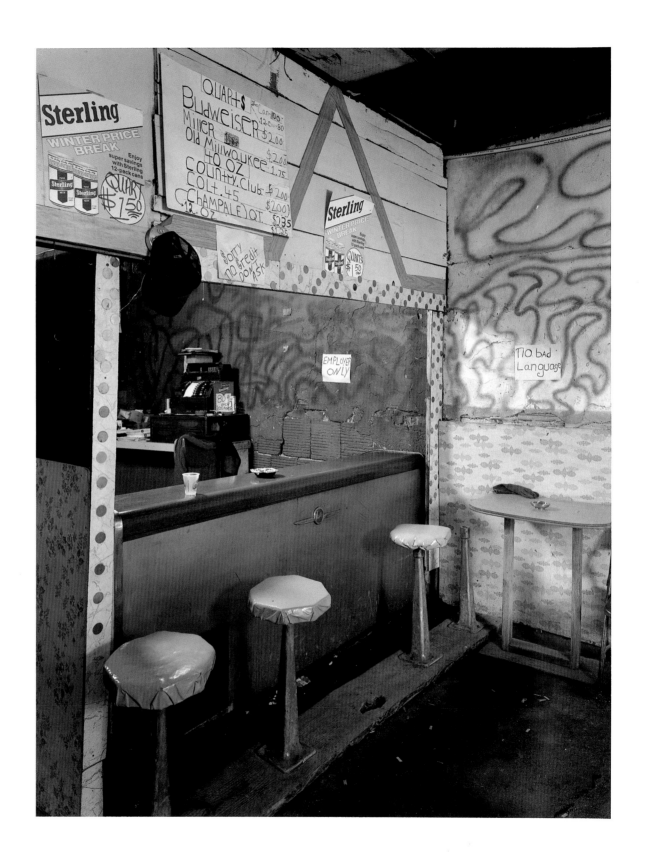

37

Chinese Grocery, Drew, 1984

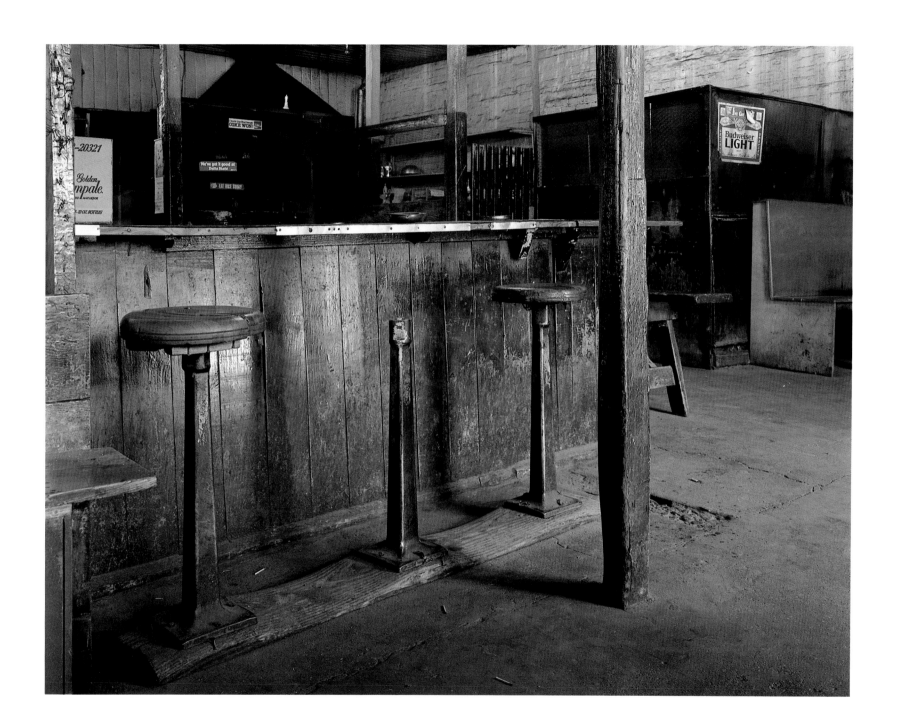

38

Juicy's Place, Marcella, 1984

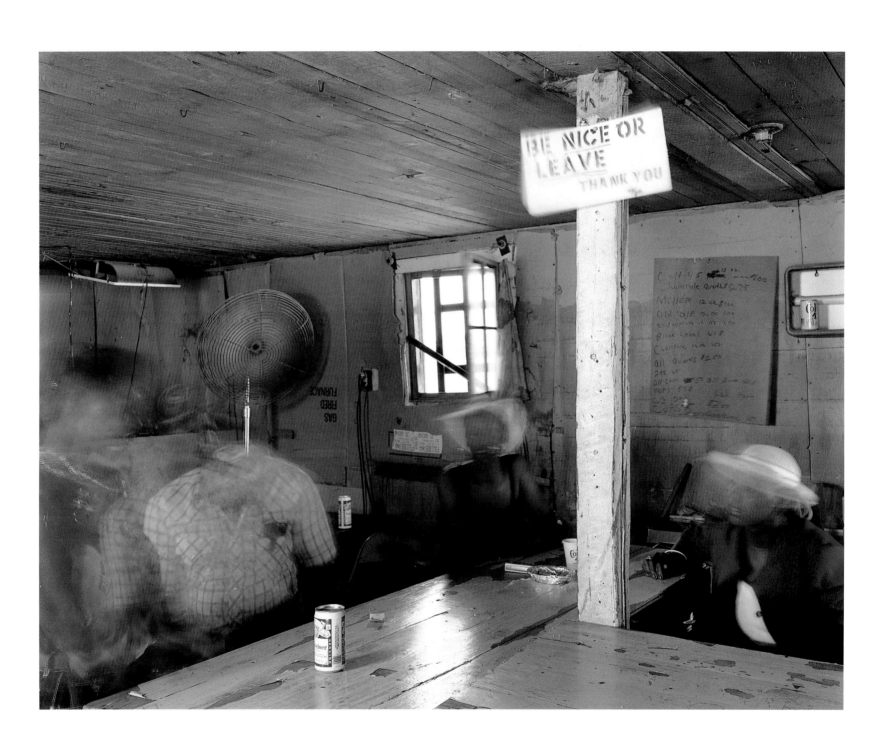

39

Blue Lite Disco, Rosedale, 1984

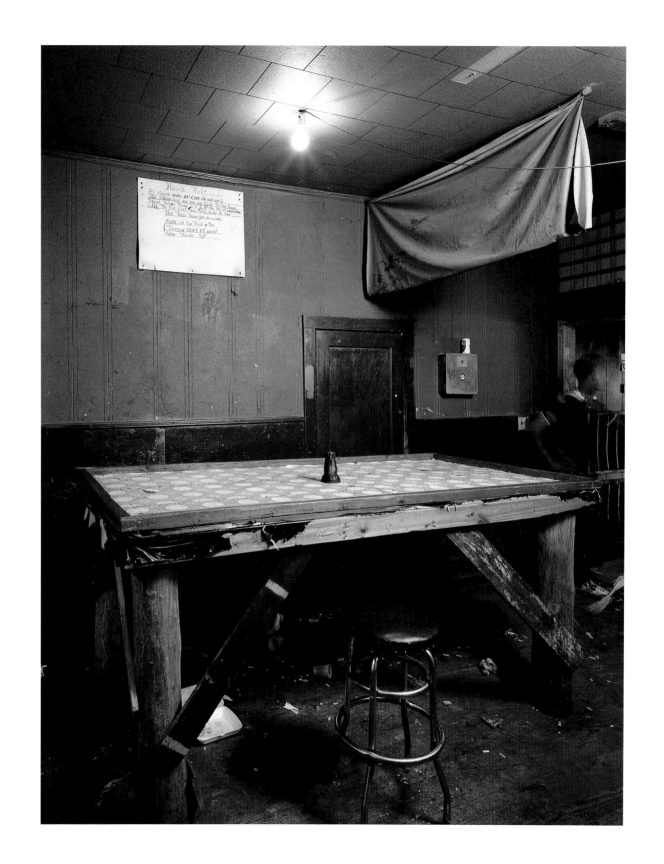

40

Arcola Cafe, Arcola, 1985

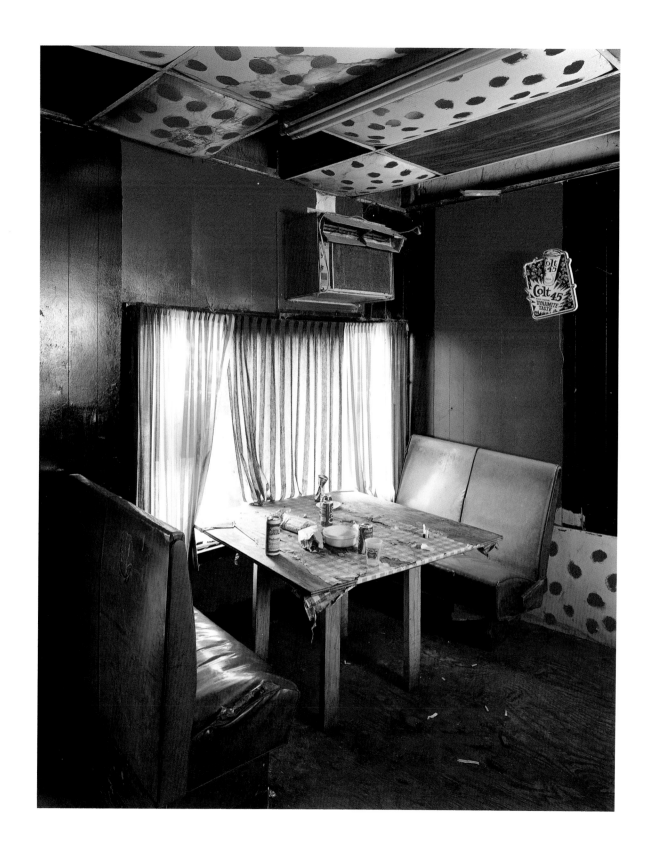

41

A. D.'s Place, Glendora, 1986

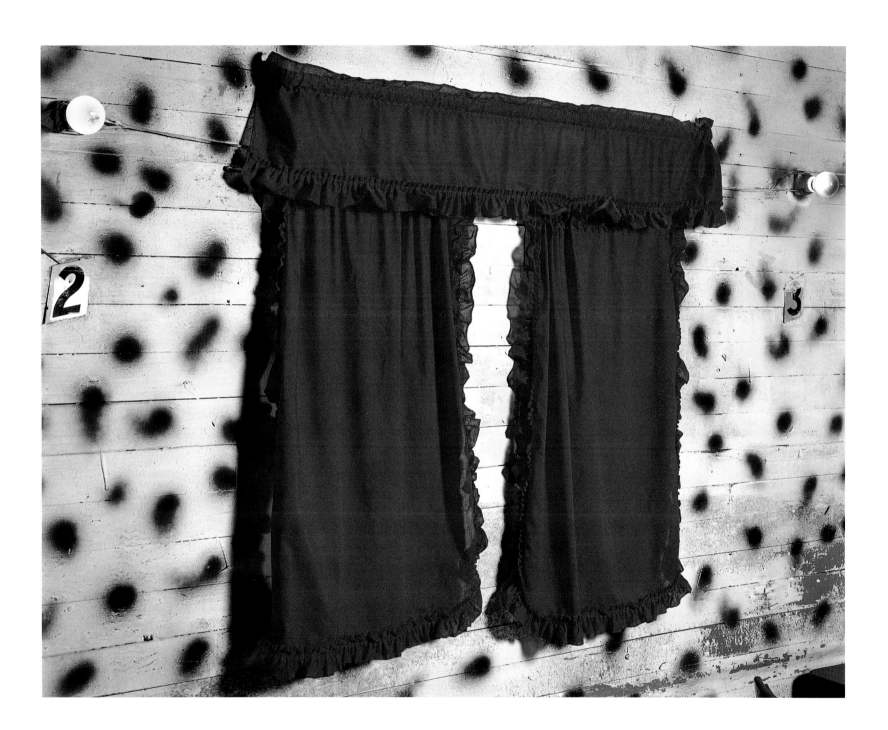

42

Piney's Place, Warren County, 1989

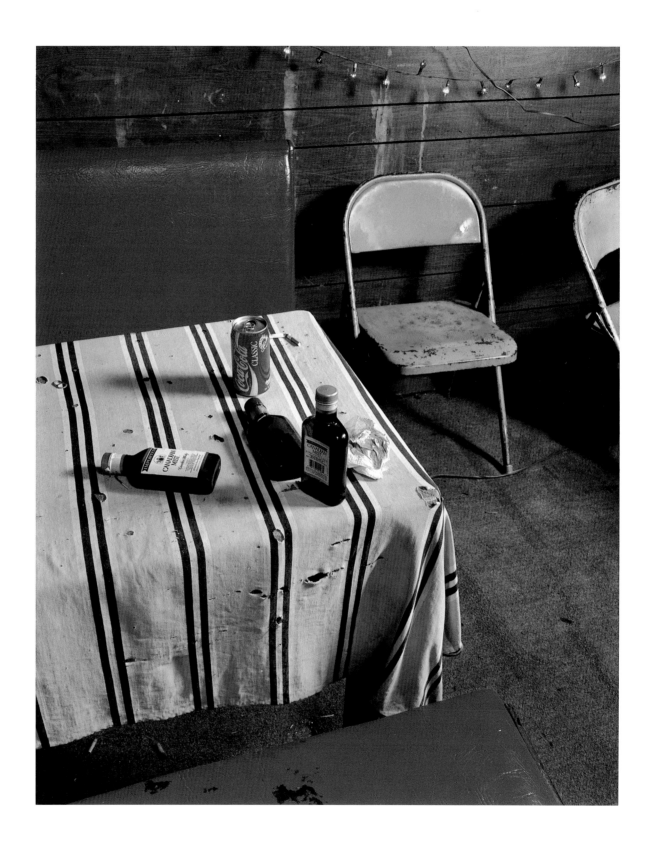

43

Mattson Cafe, Mattson, 1989

44, 45 (o v e r l e a f)

Early Wright's Place, Darlove, 1989

Ferry Club, Lowndes County, 1989

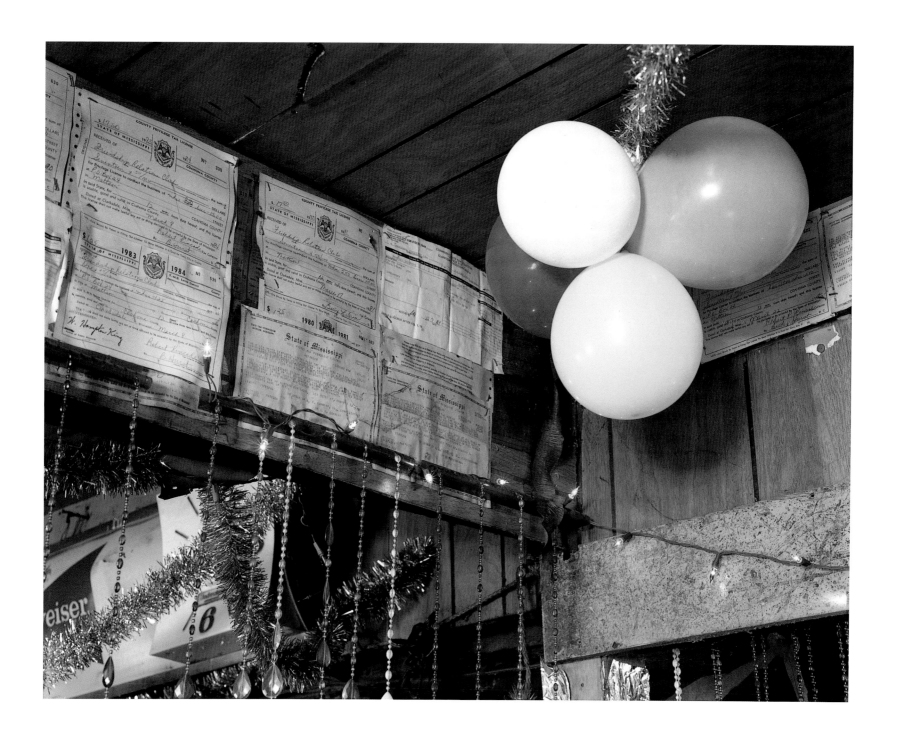

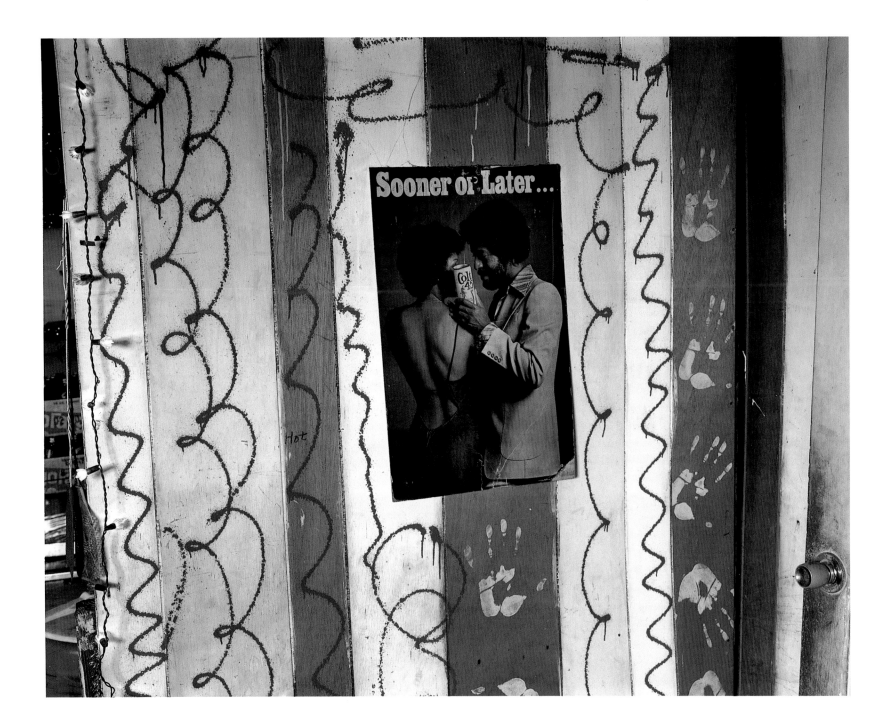

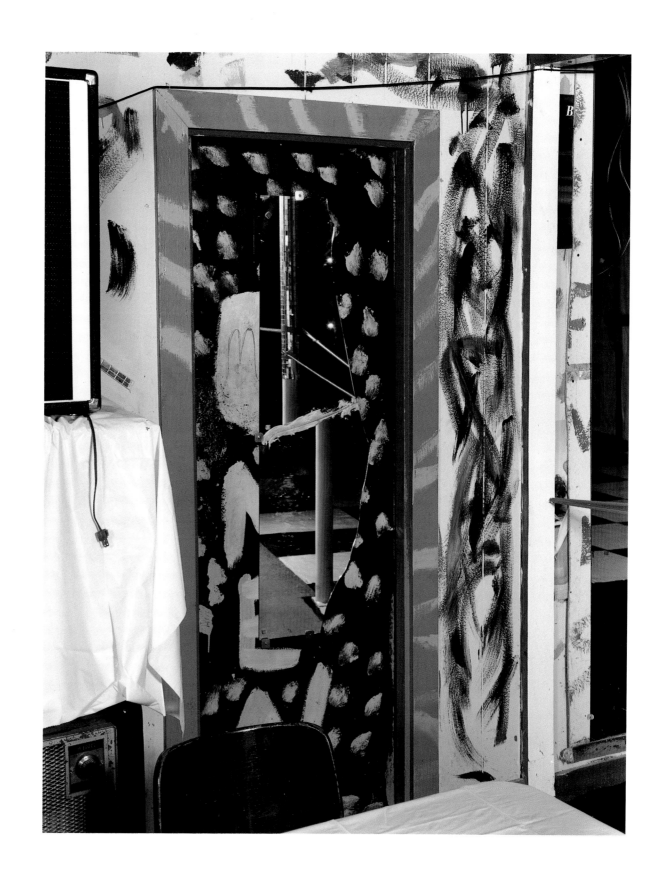

Ferry Club, Lowndes County, 1989

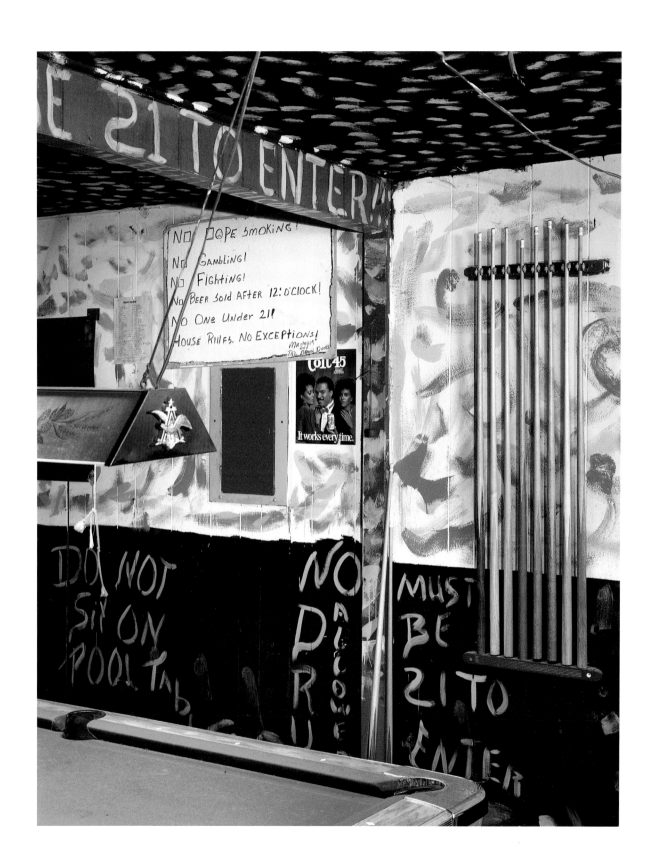

47

The Horseman Club, Crawford, 1987

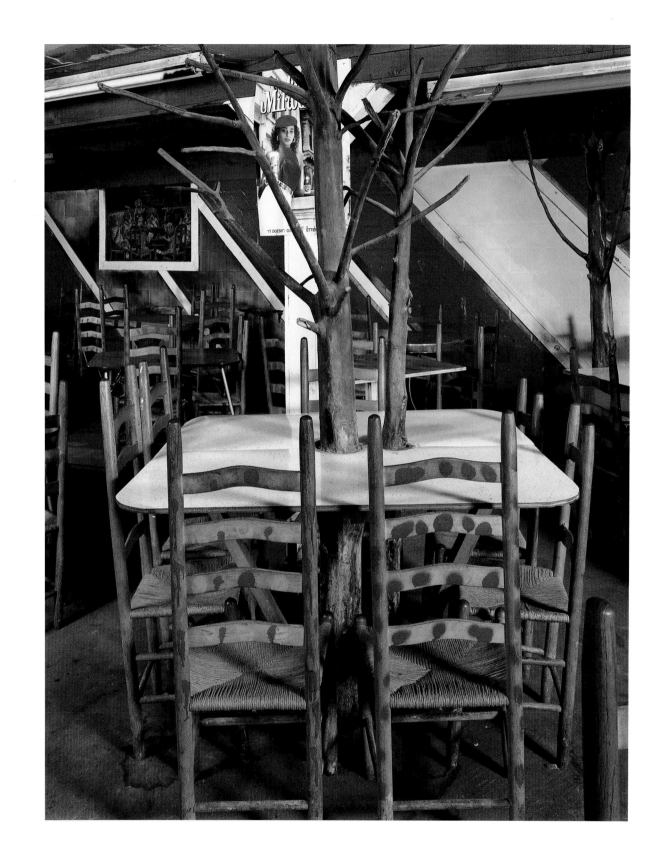

48

R. B.'s Place, Sumner, 1989

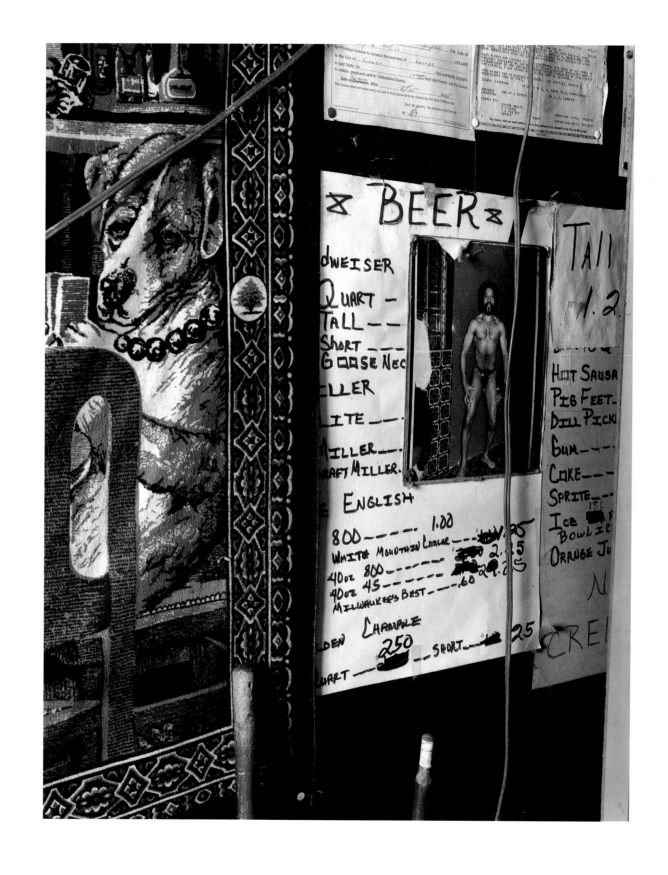

49

Seal's Cafe, Carey, 1989

50, 51 (o v e r l e a f)

The Social Inn, Gunnison, 1989

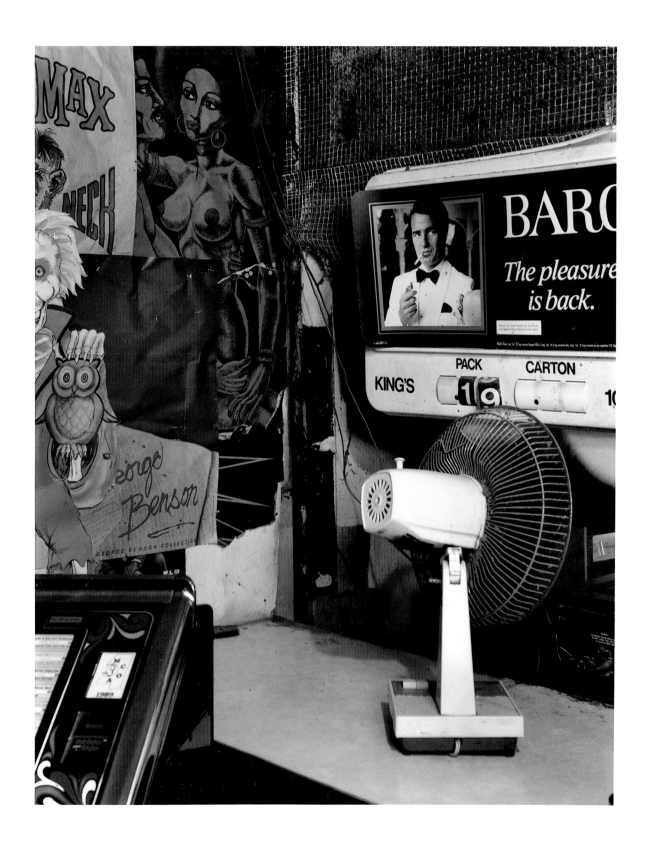

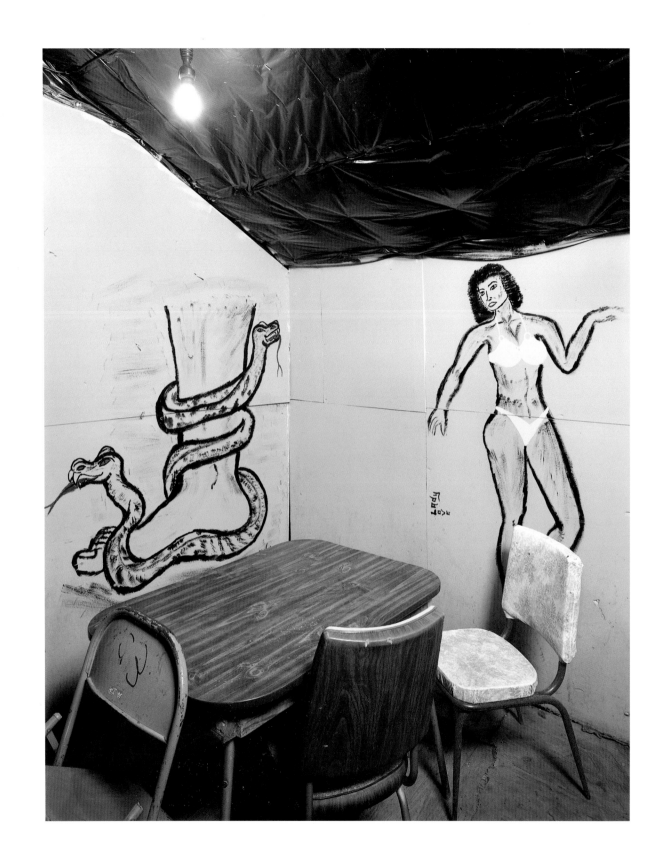

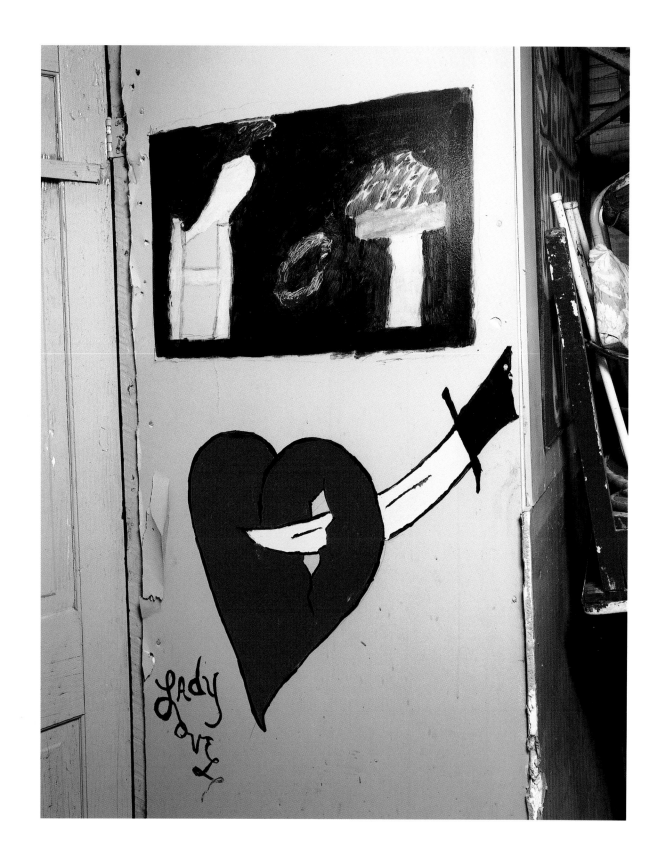

52

Monkey's Place, Merigold, 1989

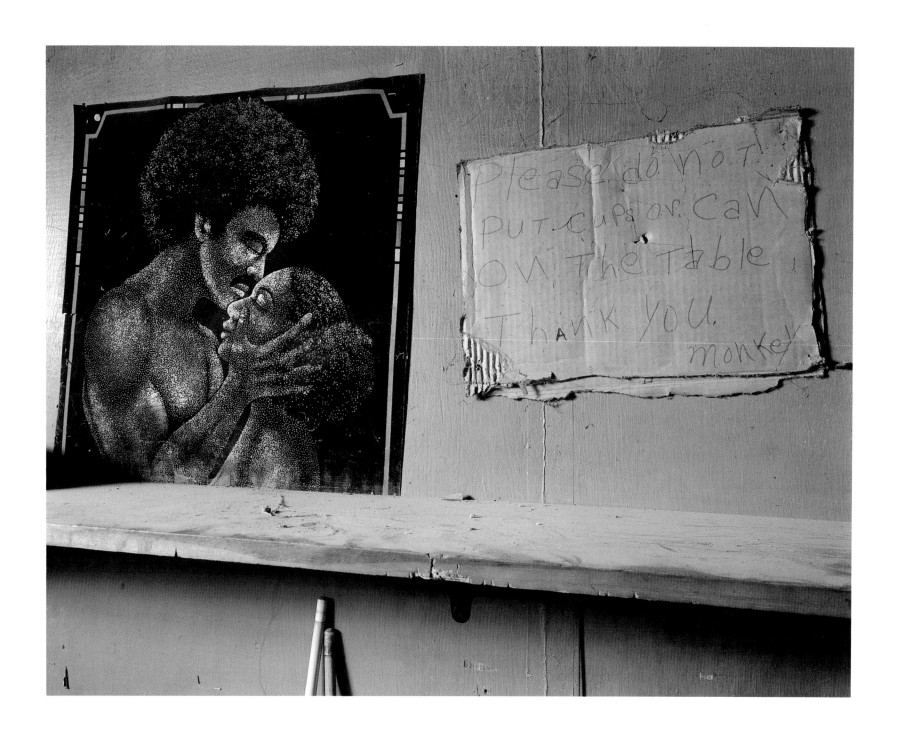

53

Yank's Place, Rosedale, 1989

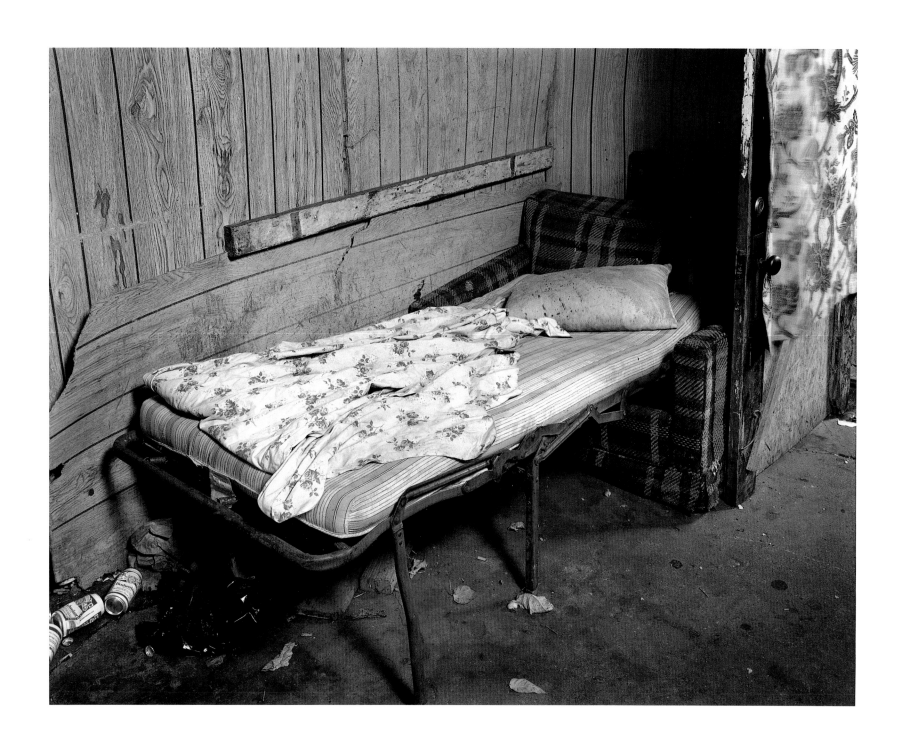

54

Mattson Cafe, Mattson, 1989

55, 56 (overleaf)

Freedom Village Juke, Washington County, 1985

Near Falcon, 1984

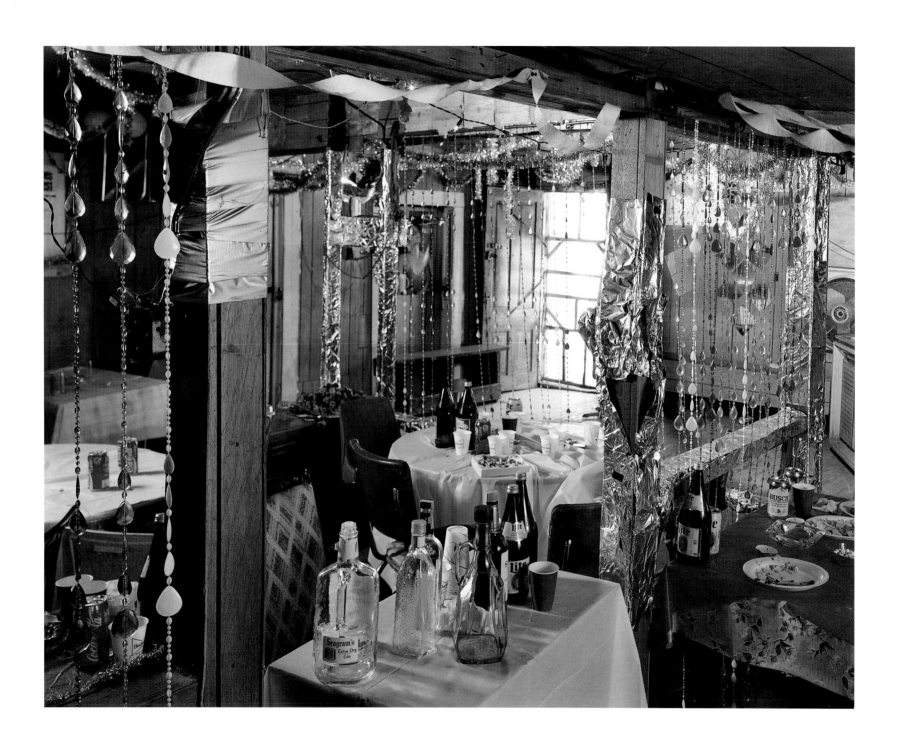

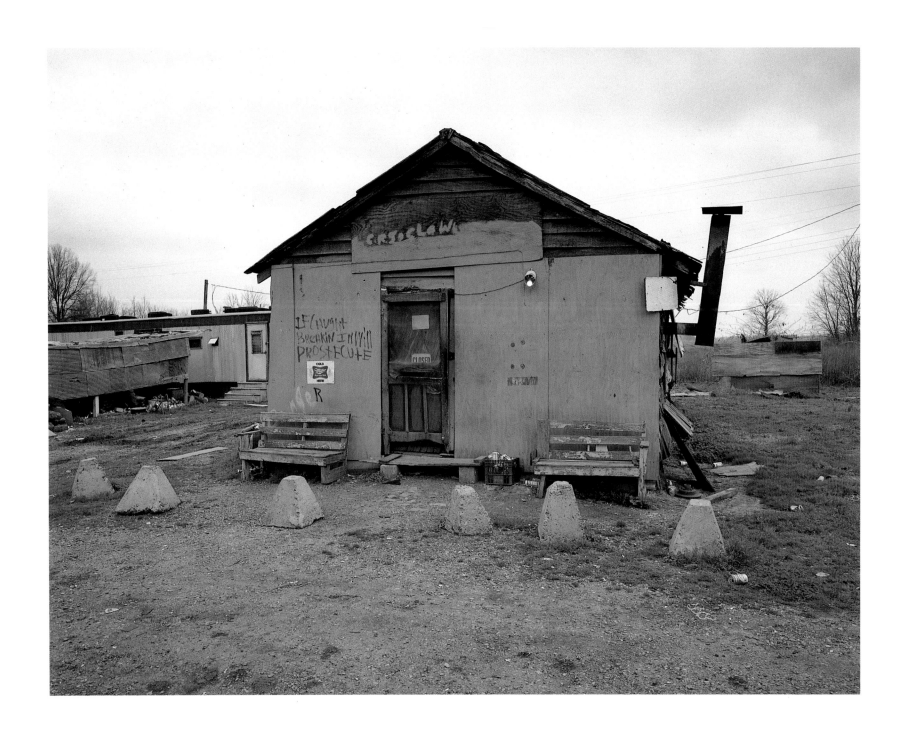

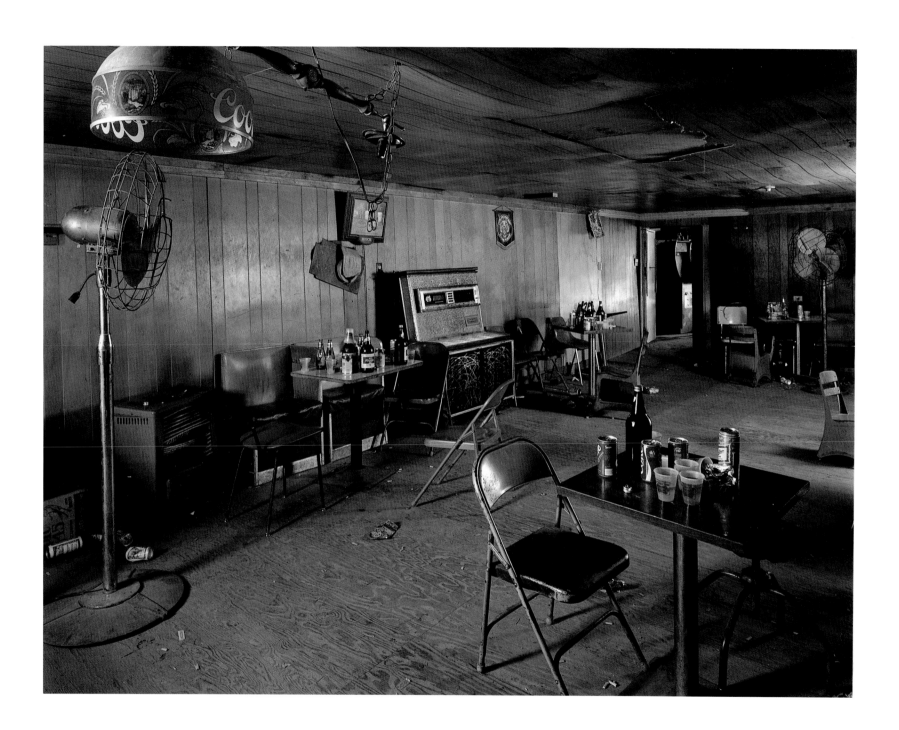

57

Magic City, Falcon, 1989

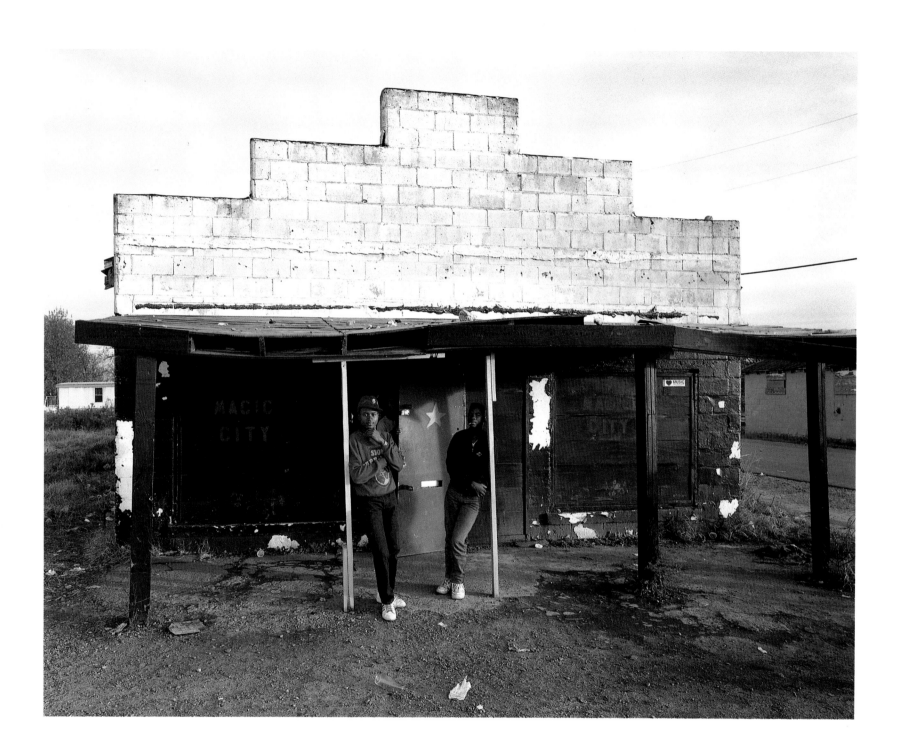

58

Turk's Place, Leflore County, 1989

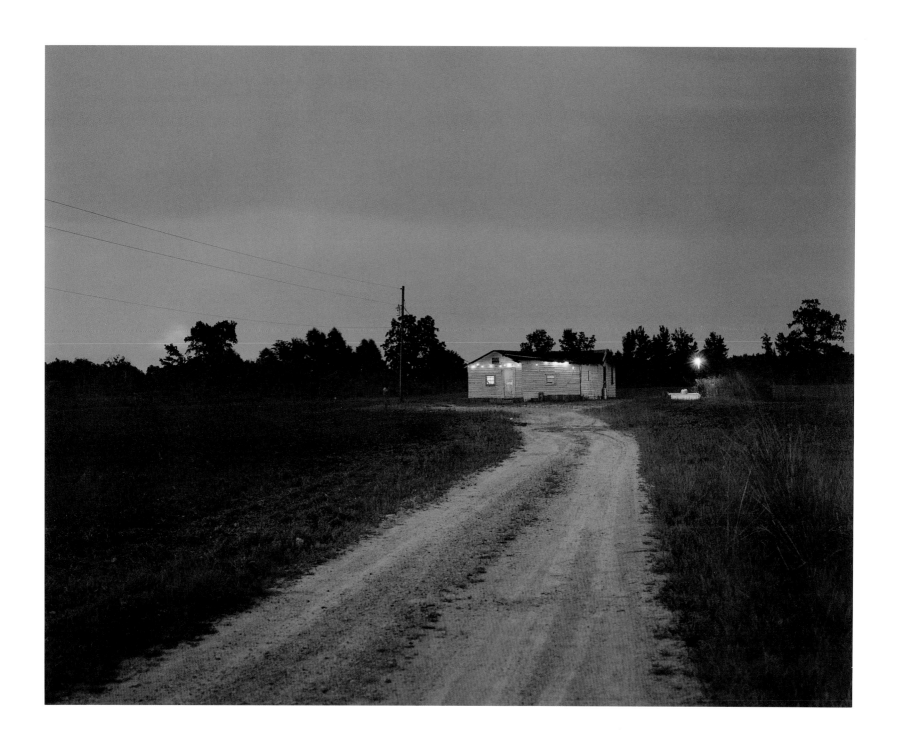

AFTERWORD

Growing up white in the segregated South of the 1950s, I was only vaguely aware of another culture, another world that existed in the midst of my own. As a child I saw things out of the corner of my eye, but the question of race was one I never had to face straight on. When my high school was integrated in the late sixties, the veil began to part, and I started to see the richness and diversity of a culture that till then had been hidden from me. When I began photographing six or seven years later, it was in part my wish and my need to overcome this ignorance that helped make my choice of subject an obvious one.

In 1983 I began photographing the juke joints. Before that I had been photographing people and events in rural Mississippi using black and white film in a rollfilm camera. In this work I went where people gathered to visit and socialize. Often this would be a juke joint, and as I spent more time in these places, I came to see the juke joints themselves as subjects.

Most of the pictures in this book were made with a 4 × 5 view camera mounted

on a tripod. For the interior photographs I used quartz lights mounted on stands, usually reflected into small umbrellas. When necessary I adjusted the intensity of my lighting with a rheostat, which allowed me to preserve the effect of the ambient light. Over the course of this project I have used a variety of films. The two that seemed best to suit my purposes are Kodak Vericolor VPL for the interiors and Fujicolor NSP for the exteriors.

Generally I prefer a small lens aperture to achieve adequate depth of field. This requires exposure times that can range from several seconds to several minutes. With exposures of this length any movement within the frame—a figure walking in front of the camera, a beer can lifted to a mouth, or a billiard ball rolling across a table—usually appears on film as a ghost-like blur. Rather than try to control this motion I usually allow these movements to take their natural course during the exposure, and it is not until I view the developed negative that I know what effect they will have on the final image.

I would like to express appreciation to the National Endowment for the Arts for the two fellowships I received during the period in which I made these photographs and to the Mississippi Museum of Art, under whose sponsorship in 1985 some of the photographs were made.

Also I thank the owners of the juke joints who allowed me, with all my equipment, to visit and to photograph in their places, often a number of times.

Thanks to Richard Ford for his eloquent introduction, to Bob Liles for his patience and the beautiful prints he has produced for me over the years, to Jim Carnes, whose advice and judgment I relied upon often as this book evolved, and thanks to the many others who have helped me along the way.

Thanks to JoAnne Prichard and John Langston at University Press: JoAnne, for conceiving the book and John, for his elegant design of it, and to both for their commitment to quality and their support throughout.

In addition to Beth, I would like to dedicate this book to my children, Peter, John, and Tanner, to my mother and father, Nancy and Birney, and to the memory of my grandmother, Eunice Tanner Imes, who first taught me with love to look and to question.

Birney Imes